# BUILDINGS OF COLCHESTER

## THROUGH TIME

Patrick Denney

AMBERLEY PUBLISHING

# Acknowledgements

I would like to thank the following people and organisations for help received in compiling this book. To begin, I would to like make special mention of my debt to the late John Bensusan Butt, whose excellent biographical indexes of Colchester people and buildings (lately edited and published by Shani D'Cruze) have proved to be a mine of information. Thanks also to Firstsite Colchester, Rafael Viñoly Architects, and photographer Richard Bryant (arcaidimages.com), for permission to include the photographs of Firstsite seen on the front cover and on page 17 (bottom), and also to photographer Patrick Squire for permission to include the aerial view on page 17. My thanks is also extended to Jess Jephcott for information received on various local public houses, and for permission to include the photograph of the Marlborough Head public house on page 32, the Colchester 24 group for permission to include the older of the two photographs of the Scheregate Hotel on page 41, Jenny McCarthy for allowing me access to her home to photograph the foundation stone shown on page 13, Jo Edwards for allowing me access to the deeds of 70 and 71 High Street (pages 24–25), Members of St James' church for allowing me access to photograph the Arthur Winsley memorial on page 20 and Peter Evans for permission to include the picture of the old Corn Exchange on page 65. Also not forgetting Ignacio González Riancho whose interest in architecture, both in Spain and locally, inspired me to compile the book in the first place. Finally, a big thank you to Brian Light for preparing the location map included on page 4.

*For Stephen and Paul*

First published 2012

Amberley Publishing
The Hill, Stroud
Gloucestershire, GL5 4EP

www.amberley-books.com

Copyright © Patrick Denney, 2012

The right of Patrick Denney to be identified as the Author of this work has been asserted in accordance with the Copyrights, Designs and Patents Act 1988.

ISBN 978 1 4456 0408 4

British Library Cataloguing in Publication Data. A catalogue record for this book is available from the British Library.

Typeset in 9.5pt on 12pt Celeste.
Typesetting by Amberley Publishing.
Printed in the UK.

# Introduction

Like many regional centres in the UK, Colchester has experienced its fair share of modern development. During the last few years alone we have seen the construction of two large shopping precincts, several multi-storey car parks and numerous other large retail stores and office blocks, all of which have replaced existing buildings and, in some cases, entire street systems, never to be seen again. However, it is not all doom and gloom. For though the town must rightly continue to progress and develop, it seems to me that in recent years efforts at town planning have been tempered with a desire to preserve the traditional character of the town, particularly with regard to our legacy of historic buildings.

Of course, we are rightly proud of our Roman and Norman heritage, as well as our stock of medieval churches, but for the most part our buildings' legacy is confined to the post-medieval period, particularly from around the seventeenth century onwards. The survivals from this period include many fine timber frame buildings, some with external plasterwork and others with their timbers exposed. On a few of the main streets you will see lines of smart Georgian townhouses with their impressive red-brick façades and classical doorcases, while in the High Street you will find rows of richly decorated Victorian and Edwardian shopfronts – that is, of course, if you care to look above the ground floor plate-glass windows. But regardless of the style, or the period from which these buildings originate, they collectively stand as part of our rich local heritage and every effort should be made for their preservation.

This book will take the reader on a tour of such buildings, all located within easy walking distance of the town centre. More than 200 colour photographs have been used to illustrate what can be seen from a street perspective, and the supporting text serves to provide information on both architectural detail and general points of interest. Those who wish to explore further, and perhaps cover even more ground, are advised to refer to the publications recommended for further reading, as well as the Glossary of Terms found on page 94.

I hope that you enjoy reading the book as much as I have enjoyed preparing it.

## Recommended Further Reading and Websites

Bettley, J. & Pevsner, N. *The Buildings of England: Essex*, Yale University Press, 2007
*Royal Commission on Historical Monuments: Essex (North East)*, HM Stationery Office, 1922
www.colchesterhistoricbuildingsforum.org.uk Searchable database of local buildings
www.imagesofengland.org.uk English Heritage: images of historic buildings in England
www.britishlistedbuildings.co.uk Searchable database of listed buildings in Britain

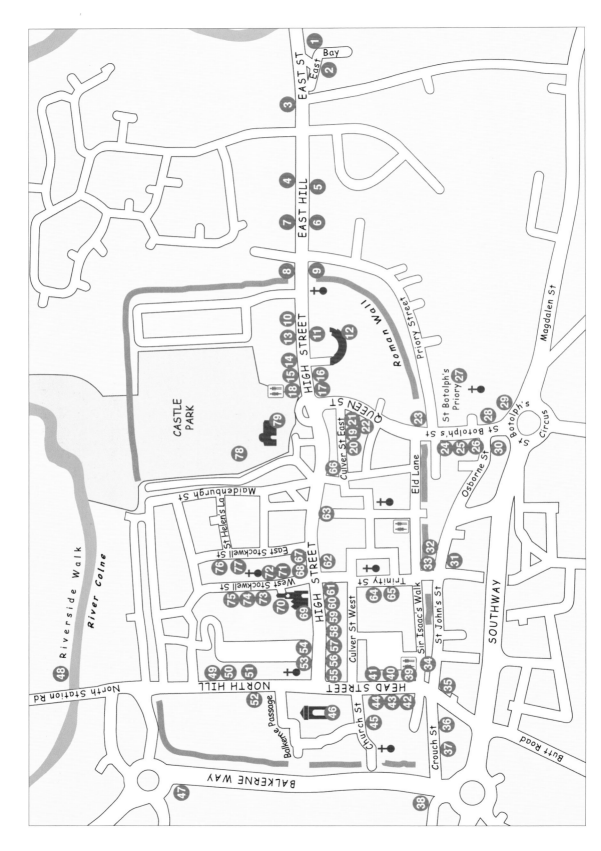

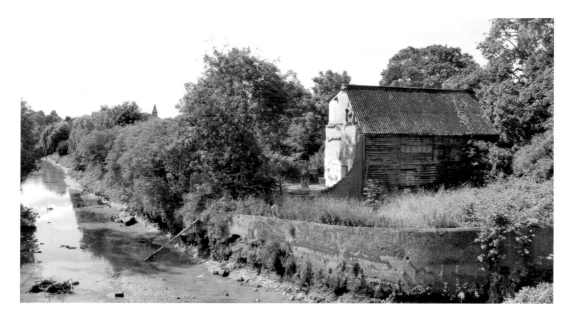

## Doe's Mill

This rather drab-looking building sitting by the river at East Bridge is a former granary known as Doe's Mill and dates from the eighteenth century. Despite its derelict appearance, and some severe alterations to its structure, the main framing of the building would appear to be pretty much intact. The building's west elevation is a little more pleasing to the eye and shows a large doorway at first-floor level with a smaller opening in the gable. Interestingly, a thatched version of the building appears on an eighteenth-century watercolour by the artist Edward Eyre (see detail below).

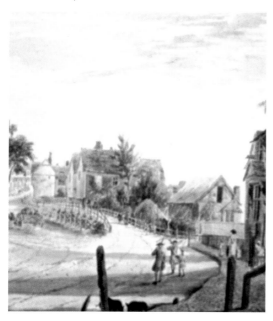

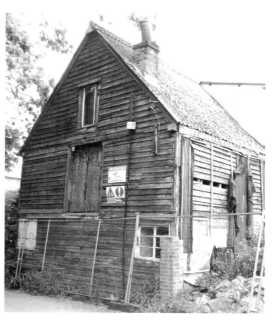

*Left*: East Bay looking east, *c.* 1775.

*Right*: West elevation with timber-cladding.

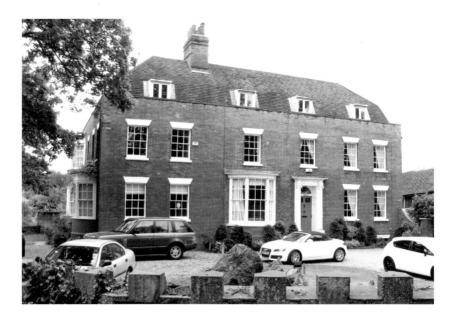

### East Bay House

This substantial red-brick Georgian house would appear to date from the late eighteenth century (it was described in 1807 as having been built but a few years), and enjoys a pleasant frontage on both its north and east-facing sides. The building is of two storeys with cellars, attic and dormers within the Mansard roof. Both frontages have similar features, including parapet, bay windows, and doorcases with attached Ionic columns and painted stone dressings to the windows.

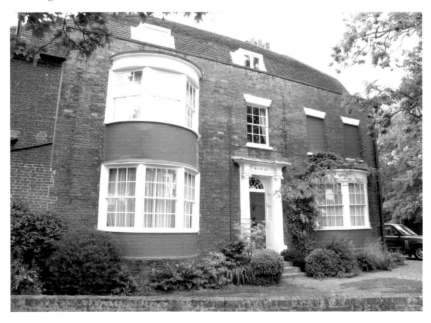

The eastern aspect with both single and double bay windows.

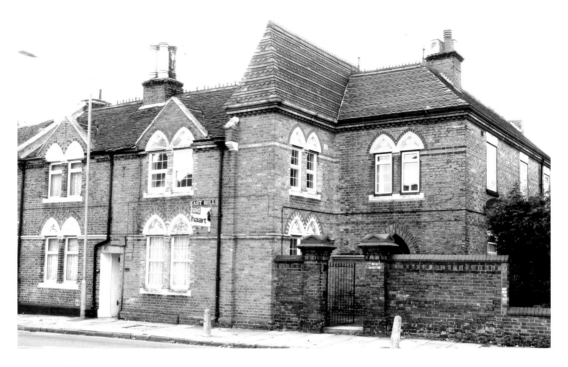

### 55 East Hill (Former Orphanage)

This building began its life as an orphanage and industrial school for girls in 1871. It is a good example of High Victorian Gothic architecture with its steep, decorated tiled roof and pointed arched windows. Note also how the red-brick and stone dressings stand out from its yellow-brick construction. The building was designed by Horace Darken and built by Mr A. Diss of West Bergholt. The construction costs, which amounted to nearly £700, were fully subsidised by Mrs Margaret Round of East Hill House.

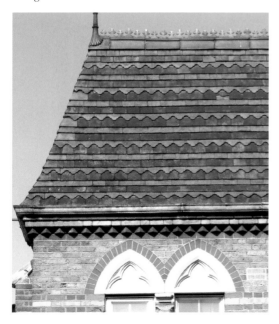

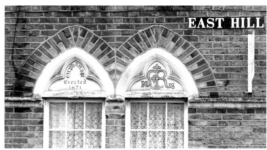

*Above:* Brick and stone window arches with foundation date.

*Left:* Decorative roof tiles and an ornamental brick cornice.

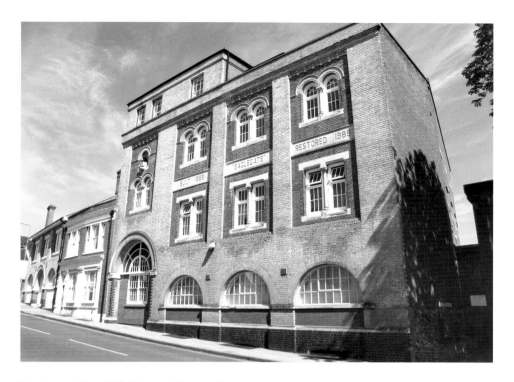

### Eaglegate, East Hill (Former Brewery)

This is the former entrance block to the Colchester Brewing Company, established in 1888. An earlier concern, set up by the Hurnard family, and known as the Eagle Brewery, had been operating on the same site since 1828. The decorative façade rises to three and four storeys and presents an interesting pilastered and arcaded display of red and grey brick. The carriage archway and triple lunette windows on the ground floor contrast nicely with the square-headed and double-arched windows at a higher level.

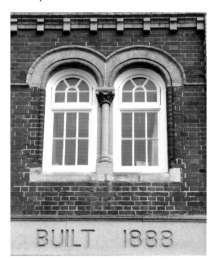

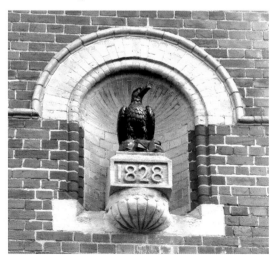

*Left*: Double round-headed window with colonnette.

*Right*: The emblem of the Eagle Brewery.

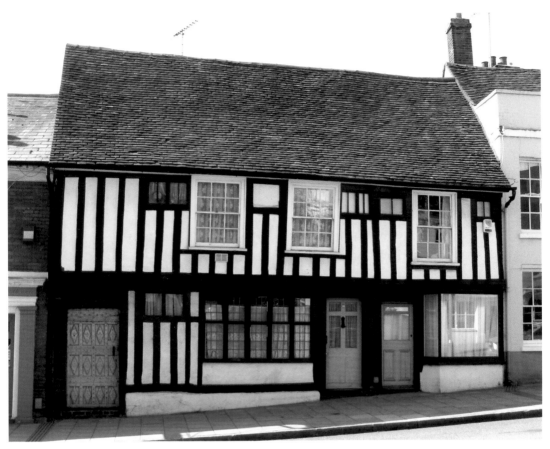

## 16–17 East Hill

*Above*: This sixteenth-century timber frame house has been subject to various alterations over the years, but there is still much to admire from the original construction. Note the overhanging upper storey, the row of original windows beneath the eves (now mostly blocked up), and especially the door, which consists of twelve moulded lozenge-shaped panels.

*Left:* Sixteenth-century door.

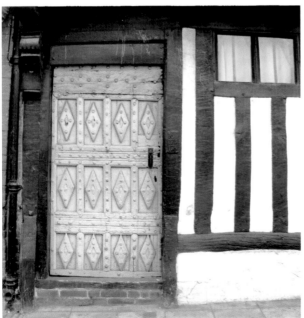

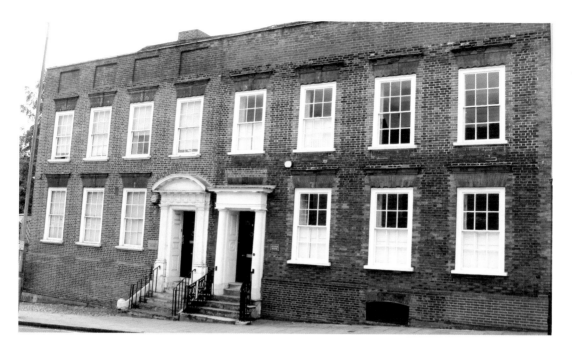

### 9–10 East Hill

Small slim-line bricks, window frames set almost flush with the brickwork and exposed sash boxes should be enough to place this fine pair of Georgian townhouses to the early part of the eighteenth century. And indeed surviving property deeds would suggest that the building of the brick front may date from as early as 1715. The house was originally a single dwelling and was divided as it now appears in 1810. If you look above the right-hand doorcase you can see the remains of the brick arch of an earlier window. Part of the parapet has also been rebuilt. The left-hand doorcase is Roman Doric with a segmental pediment.

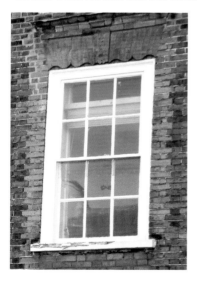

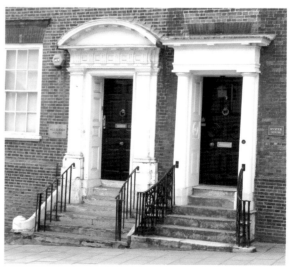

*Left*: Flush fitting sash window with elaborate gauged brick arch.

*Right*: A Roman Doric doorcase on the left and Tuscan style on right.

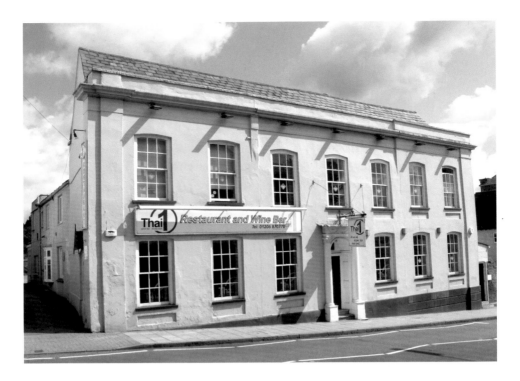

## 82 East Hill (Thai Restaurant)

This is a good early Georgian house with a range of seven windows with segmental heads. The style appears to be somewhat later than that displayed at 9–10 opposite, particularly with regard to the window frames, which are set back from the face of the brickwork – although the sash boxes are still visible. This would indicate that building work took place at a time when new building regulations were starting to be enforced, requiring that all sash windows be set back four inches from the outer wall. The plastered front fails to make such a bold impression as does the brick-fronted building opposite.

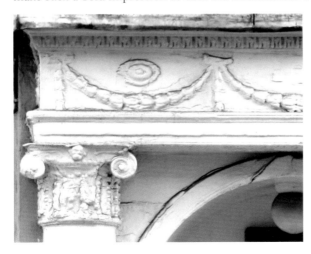

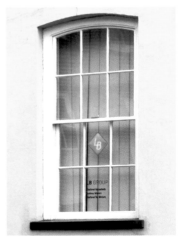

*Left*: Detail of Composite-style capital and frieze with swag decoration.

*Right*: Recessed sash window with exposed sash box.

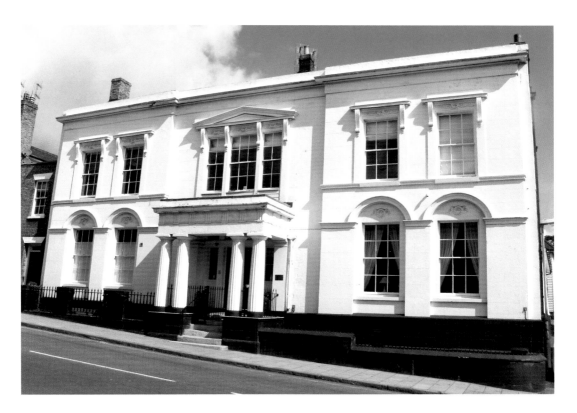

### 86 East Hill (Belgrave House)

This large and imposing building was erected in 1817 for the Revd John Savill of Lion Walk Church. The stucco front is highly decorative with a range of five windows surrounding a large Greek Doric porch. The four columns each contain twenty flutes, as dictated by the Greek order, with the outer triglyphs in the frieze correctly terminating at the angles, rather than centrally over the columns as in the Roman order.

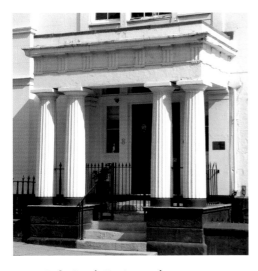

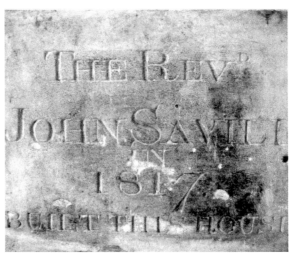

*Left*: Greek Doric porch.

*Right*: Foundation stone in basement.

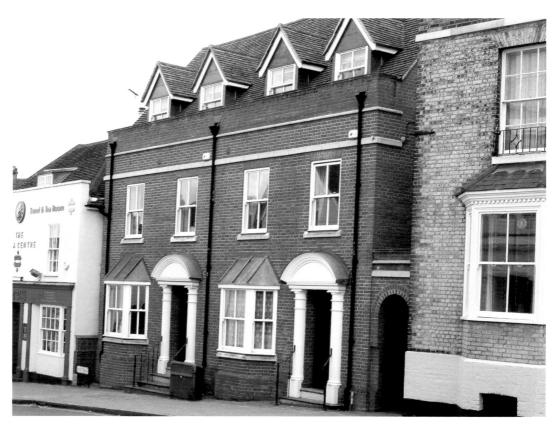

## 4–4a East Hill

*Above*: This modern pair of brick houses was designed to slot seamlessly into the historic character of East Hill. They certainly have a Georgian feel about them, with their rooftop dormers, parapet wall, sash windows and classical-style doorcases. A thumbs-up, I think, to modern developers.

*Left:* Plain Roman-style classical doorcase.

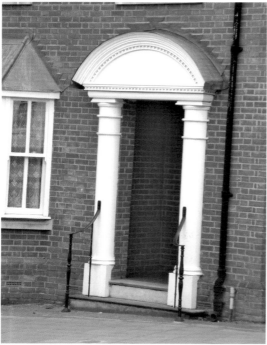

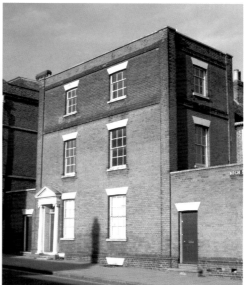

**All Saints House**

*Above right*: Here we have a late-eighteenth-century building of red brick with stone dressings (the rear part of the house appears to be older). By this date, not only are window frames being set back four inches from the outer brickwork, but the wooden sash boxes are now completely hidden behind the brickwork – all to reduce the risk of fire. The columns making up the doorcase contain an interesting mix of Ionic capitals and Doric-style fluted shafts. One wonders whether this was an intentional mismatch of classical features.

*Above left:* Sash window with hidden sash boxes.

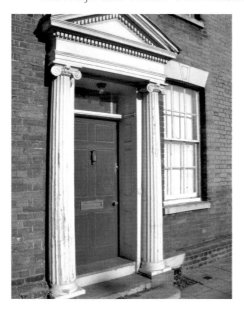
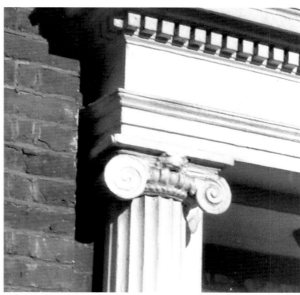

*Left*: Doorcase with Ionic capitals.  *Right*: Ionic capital resting on Doric shaft.

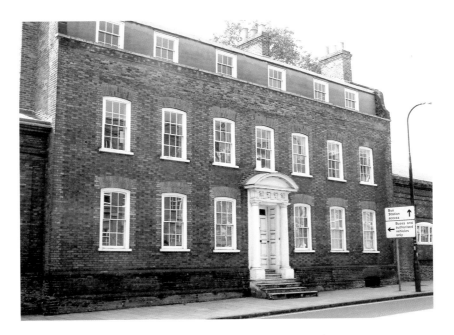

**East Hill House**

This fine Georgian building, once known as Berryfields, was built in the early eighteenth century by George Wegg, a prosperous citizen of the town. The top storey was added in the 1740s, possibly by his son (also George) who inherited the property. The house was originally surrounded by around nine acres of garden land, which was bordered in part by the Roman wall. The front contains a range of seven windows with segmental gauged brick arches. The Doric doorcase has a segmental pediment below which is a decorated Roman frieze.

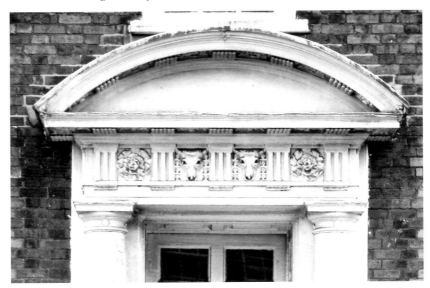

Bucrania (ox skulls) and flower motifs were often displayed in the Roman Doric Frieze.

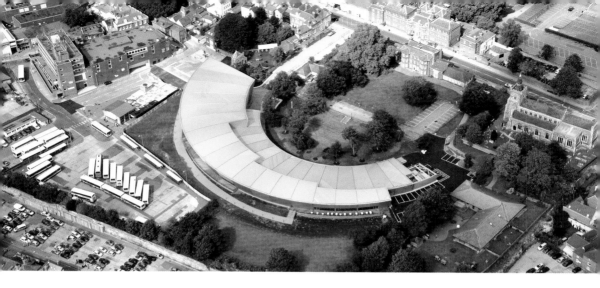

## Firstsite

However one describes the new Firstsite building, whether it be ultra-modern, cutting-edge, innovative or even shocking and unsightly, it is certainly different. The new building opened on 25 September 2011 and is considered to be one of the largest contemporary art venues in the country. The design was by Rafael Viñoly Architects, whose scheme was selected from a worldwide competition of over 100 submissions. The building's unique curved design, which was engineered to protect any underlying archaeology, extends to some 3,200 square metres and will provide permanent gallery space for major international exhibitions, as well as supporting a range of other community based activities and events. Whatever one's view of contemporary art, this building cannot fail to impress.

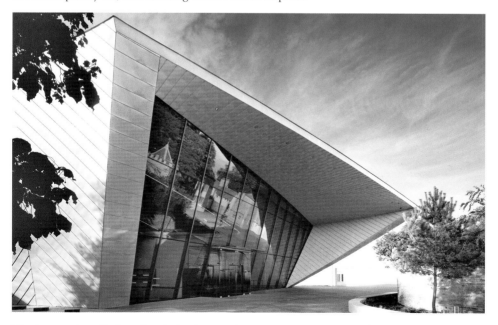

The impressive all-glass façade leading to the main reception area. The building is covered in TECU® Gold, a copper-aluminium alloy, providing a golden colour to the exterior.

**Grey Friars (Front)**

The row of buildings known as Grey Friars consists of a mid-eighteenth-century house with early-twentieth-century additions on either side. The original building was constructed for the Revd John Halls (Rector of Easthorpe) in 1755 and is a good example of a classic Georgian house. At parapet level there is a heavy modillioned cornice and pediment, below which is a Venetian window with Ionic columns. The impressive Ionic doorcase (quite suitable for the residence of a clergyman) is flanked on either side by a matching pair of two-storey bay windows that rise to the parapet. Note also how the stone string courses have been incorporated in the side extensions.

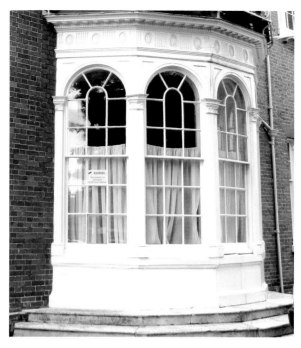

## Grey Friars (Garden Front)

*Below*: The rear elevation of Grey Friars, albeit a little later in date, has some equally impressive features. Beneath the modillioned cornice is a two-storey bay window, flanked on both floors by Venetian windows. The lower bay continues with the building's classical theme, whilst the one above displays a more Gothic approach.

*Right*: Ground floor bay with classical embellishments.

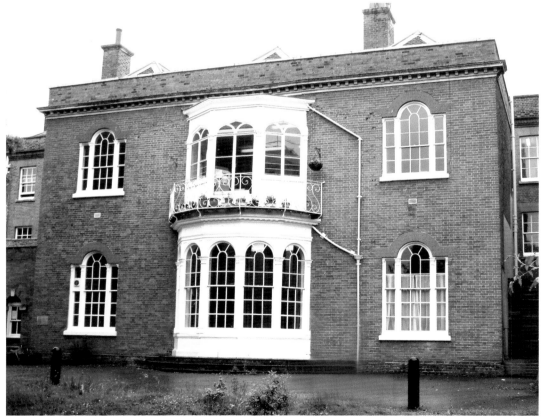

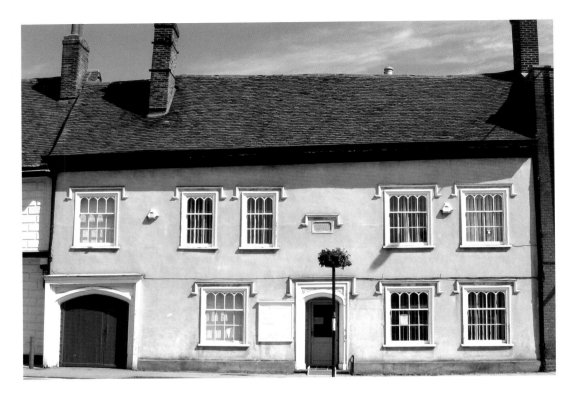

## 85 High Street (Winsley's House)

This house is named after Arthur Winsley who lived here from 1719 until his death in 1728. However, the building in its present form would appear to date from around 1705 when it became the property of local architect James Deane. By 1707 it was recorded that he had 'lately repaired and beautified it'. The plastered façade depicts a Gothic style with pointed heads to the upper sash frames and hood mouldings over the windows.

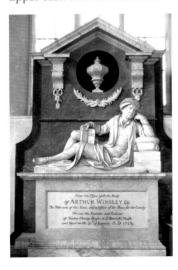

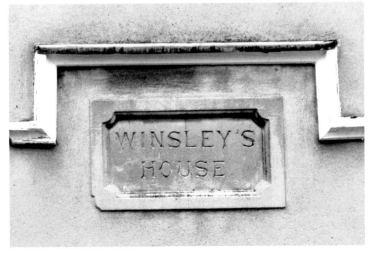

*Left*: Arthur Winsley's monument in St James' church.

*Right*: Name plaque with hood moulding.

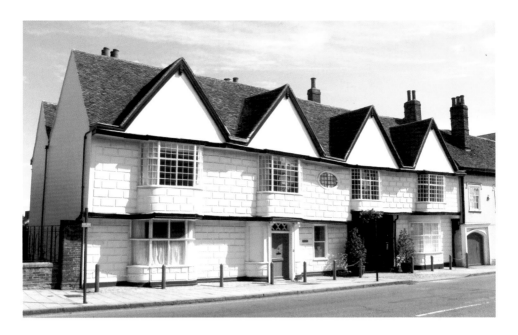

## 83–84 High Street (Gate House and East Lodge)

This is a very fine late Elizabethan building, which was re-fronted for William and Sarah Boys in 1680 (see date mark on jetty bracket). The symmetry of the gables and the projecting upper bays is particularly striking and blends nicely with the rusticated plasterwork. On the ground floor are two more curved bays, with entrance door and carriageway.

Curved upper bay windows with rusticated plasterwork and gables.

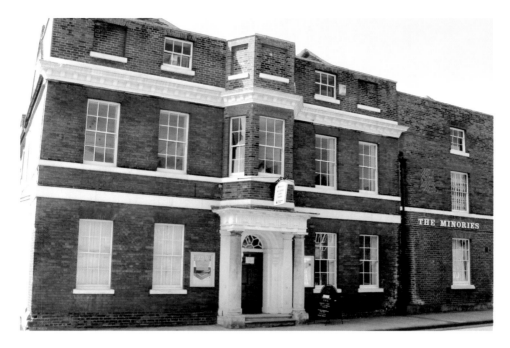

## The Minories

This early-sixteenth-century timber frame structure was remodelled into a fashionable Georgian home by Thomas Boggis in 1776. The stylish brick front was super-imposed onto the projecting upper floors of the old building, with the ground floor wall moving outwards onto the pavement. The added Doric porch encroached even further into this space. Note the modillioned cornice and horizontal bands, or string courses, particularly prominent between ground and first-floor levels. Of special interest is the two-storey canted bay, which is supported by the pillared porch – an unusual feature.

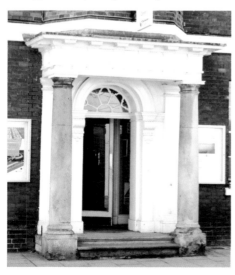

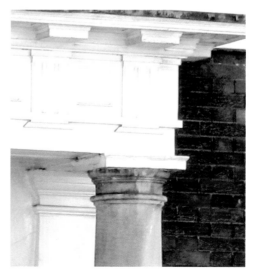

*Left*: Roman Doric porch supporting upper bays.

*Right*: Detail of column head and triglyphs in frieze.

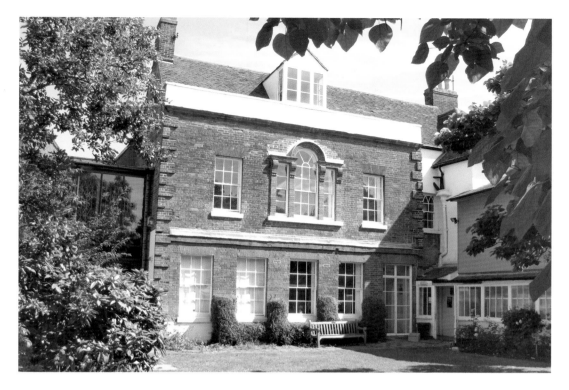

## The Minories (Garden Front)

The garden elevation as seen from the outside cafeteria area shows a brick façade with painted parapet and dormer, below which is a central Venetian window. Note the brick cornice and quoins. The Gothic-style summer house, by James Dean, *c.* 1745, may have been inspired by Batty Langley's Umbrello, which was designed to provide a resting place at the end of a garden walk. This walk was originally part of the garden of East Hill House and was divided when the road leading to the present Firstsite building was made in the early 1970s.

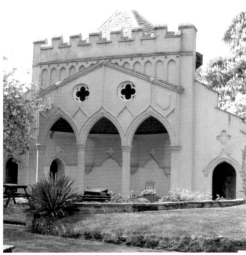

*Left*: Gothic summer house.              *Right*: Batty Langley's Umbrello.

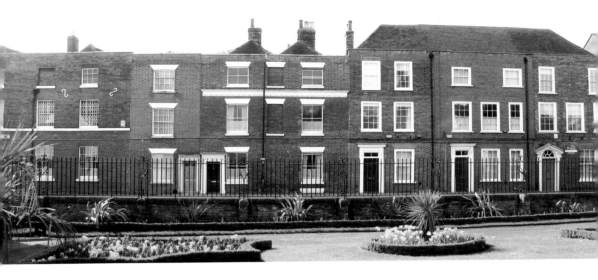

## Georgian Terrace (Nos 69–73 High Street)

This elegant Georgian terrace represents building construction across much of the eighteenth century and displays several changes in style over the period. The building on the extreme left is now part of the Minories and dates from the late eighteenth century. No. 71, seen in the middle of the row with the heavy decorated cornice, was built around 1790 by Richard Tomkins, surgeon. At some stage the building was divided into two dwellings, but has now reverted to single usage. The sign over the door claims that a former house on this site was named Nicodemes. Note also the tuck pointing on the brickwork.

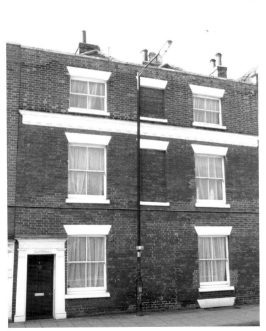

NICODEMES
A house called Nicodemes was here in 1416 when it was bequeathed by Thomas Fraunces to endow a chantry in St Nicholas Church. Title deeds of 1581 & 1665 & the modern deeds all refer to it as Nicodemes.

*Above:* The house used to be known as Nicodemes.

*Left:* No. 71 High Street.

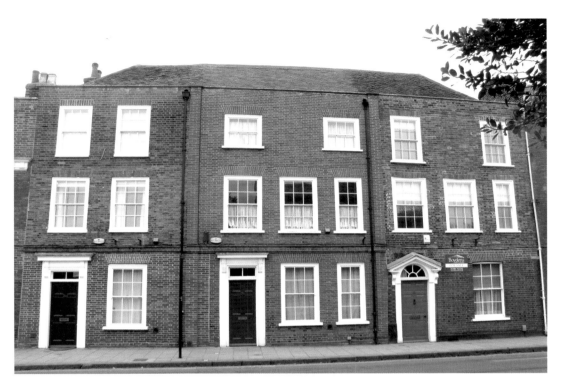

## Nos 69, 70 and 70a High Street

These three houses date from the early eighteenth century and were originally a single dwelling. By 1790, they had become two separate houses and have since been divided into three. Note the early flush fitting sash windows and small-sized bricks. The building was once owned by the well-known eighteenth-century gentleman Benjamin Strutt.

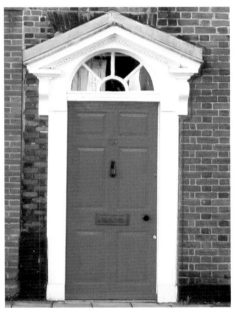

*Above:* Compare the differing brickwork of No. 71 with tuck pointing (left) and 70a (right).

*Right:* Doorcase to No. 69 with open pediment and fanlight.

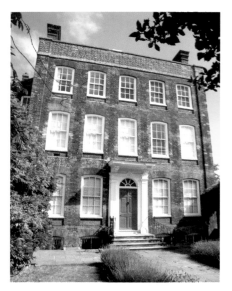

**Hollytrees Museum**

*Above left*: Hollytrees was once described as the best eighteenth-century house in Colchester. It was built between 1718 and 1719 for Elizabeth Cornelisen. By 1726 it had come into the ownership of local MP and antiquarian Charles Gray. The building is of three storeys and basement, with parapets front and back. The sash windows have segmental heads of gauged brickwork and plain brick recessed aprons below the sills. The doorcase has Doric pilasters with a flat hood supported by amusing carved consoles. Note also the tuck pointing on the facing brickwork front and back.

*Above right:* Tuck pointing.

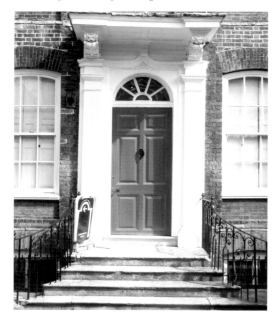

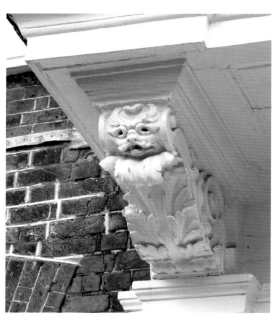

*Left*: Doorcase with fanlight and carved consoles.　　*Right*: Carved console supporting door hood.

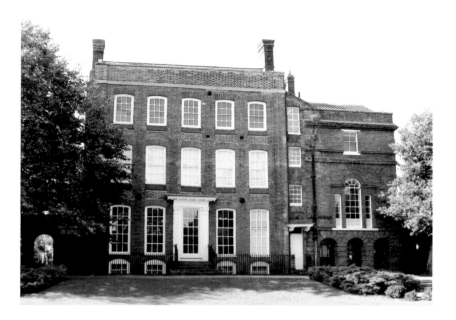

Hollytrees Museum (Garden Front)

The garden elevation is almost as impressive as the front with steps leading down from the central doorway to the manicured lawns – now part of Castle Park. The right-hand extension, which is now used as the entrance to the museum, was added by Charles Gray in 1748 at a cost of £259 4s 6d. It does contain some nice features, but lacks the style and symmetry of the main house.

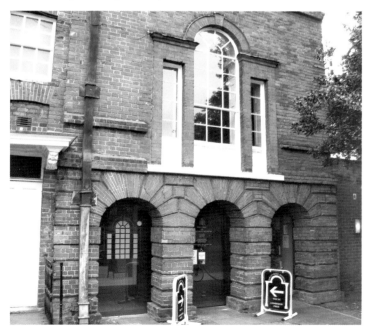

Museum entrance with Venetian window and rusticated brick arcade.

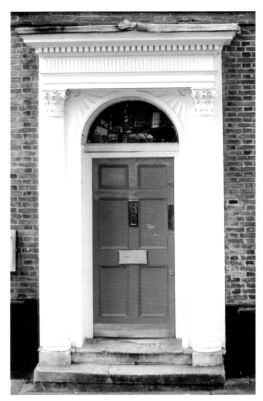

**1 Culver Street East (Prezzo Restaurant)**
*Below*: This early Georgian building (currently Prezzo's restaurant) dominates the corner of Queen Street and Culver Street East. A date on the rainwater head suggests a building date of 1743 and the initials D. I. H. stand for Jeremiah and Hannah Daniells. The building is of two storeys with parapet, attic dormers and cellars. The flush-fitting sash windows have gauged red-brick arches, which contrast well with the chequered red and blue brickwork. Note also the moulded brick string course at intermediate floor level.

*Left:* Doorcase with attached Corinthian columns and dentils in cornice.

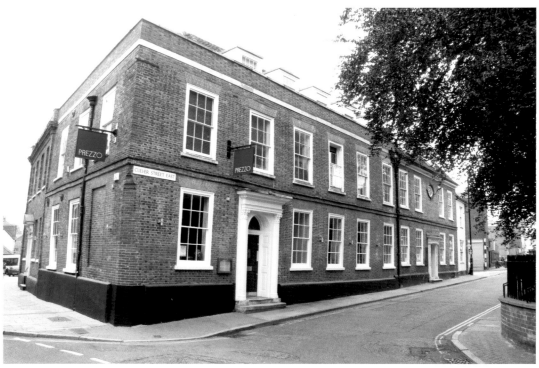

**3 Culver Street East
(Level Best Artcafe)**
*Below*: This house would appear to be contemporary with its neighbour and, indeed, both properties were owned by Jeremiah Daniell who bequeathed them to his son Peter in 1766. The chequered red and blue brickwork is more pronounced on this building and there is an oval window above its Tuscan-style doorcase.

*Right:* Rainwater head containing date 1743.

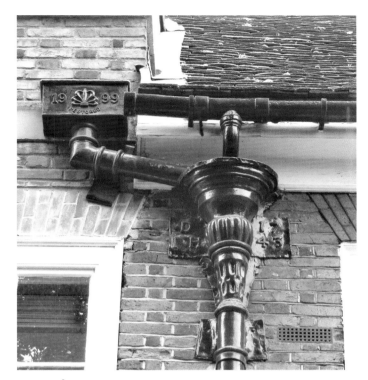

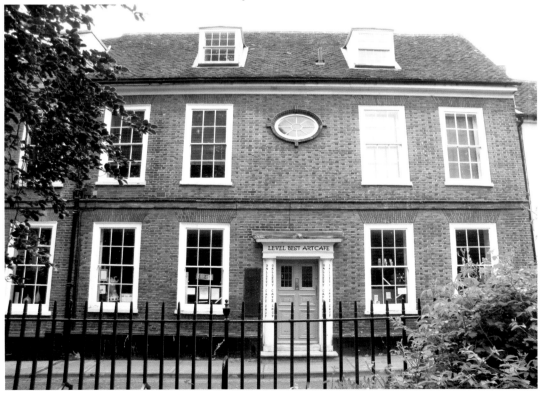

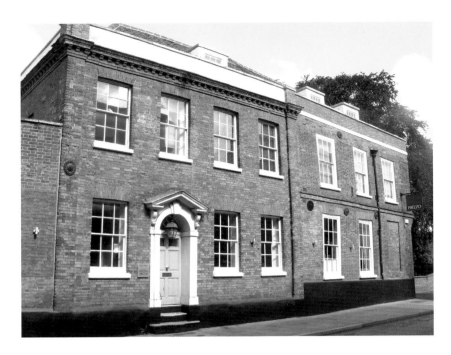

## 2 Queen Street

This house is currently incorporated into the Prezzo restaurant building adjoining, although it is somewhat later in style. Again it is of two storeys with parapet and a dormer at attic level. Below this is a modillioned brick cornice, and a range of recessed sash windows that are flanked at the corners by brick pilasters. The arched doorcase has an open pediment and fanlight.

Compare the position and style of the windows with those on the adjoining building.

## 2a–14 Queen Street (Shopping Parade)

This parade of shops was built in the early 1960s at a time when local architecture was entering a period of radical reform. Square brick and concrete boxes seemed to be the order of the day and too many of the town's architectural gems were sacrificed to make way for progress. In this case it was the turn of the fine Georgian terrace seen below.

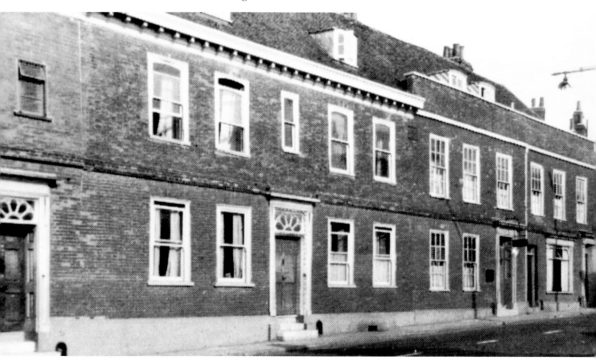

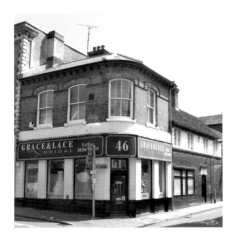 

**46 St Botolph's Street**

*Above left*: This interesting corner house is a good example of how the life of a building can change over the years. From as far back as 1750 until 1956 this was the site of the Marlborough Head public house, although the present building dates only from around 1914. A decorative wall carving of the Duke of Marlborough can be seen above the side entrance in Priory Street. The upper part of the main building is of red brick with attractive blue and grey brick bands. The sash windows have segmental arches in the same grey brick with the keystones depicted in red.

*Above right:* Decorative wall tablet of the Duke of Marlborough.

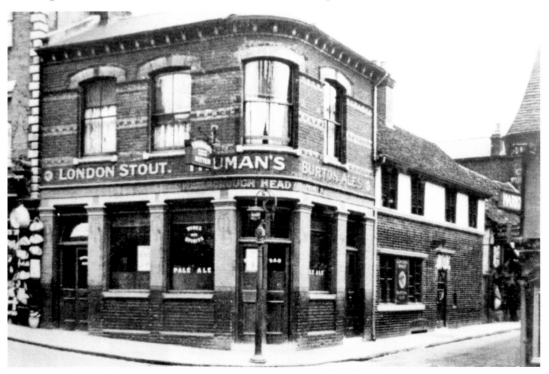

The Marlborough Head public house in the 1930s.

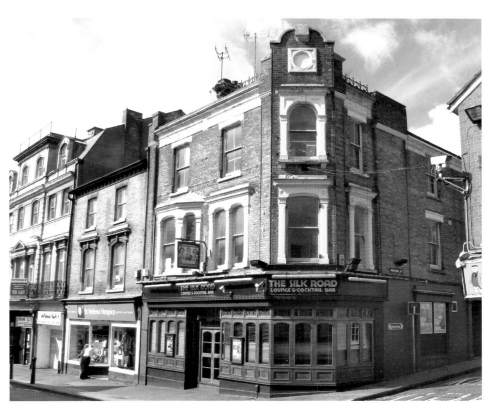

**4 St Botolph's Street
(The Silk Road Lounge &
Cocktail Bar)**
*Above*: Another interesting
corner plot dating from
sometime after 1882.
The building is of gault
brick with an interesting
assortment of stone
dressings displaying some
classical features. Note the
decorative cornice at the
eaves and the ornamental
band at first-floor window
level facing the main street.
The circular panel in the
top pediment formerly held
a clock.

*Right:* The building as
it appeared in the early
1900s as Clamp & Son's
Furnishing Store, complete
with clock *in situ.*

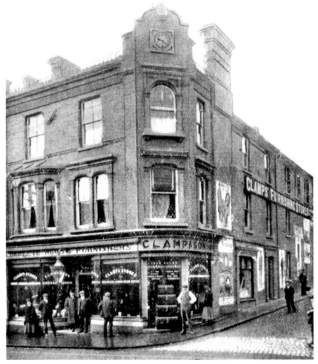

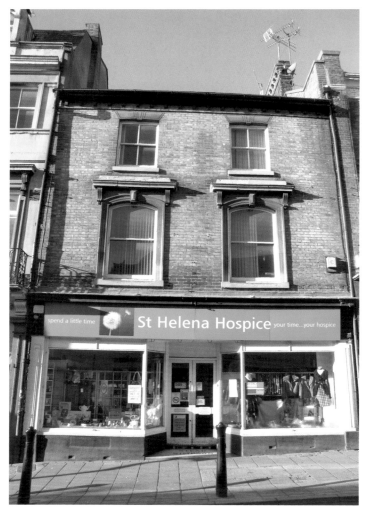

**5 St Botolph's Street
(St Helena Hospice)**

*Left*: This building would appear to date from sometime during 1883 when a number of shops along this part of the street were rebuilt following a major fire that destroyed several buildings here in August 1882. Certainly by the beginning of 1884, a new tenant, in the form of Stead & Simpson, was trading from the property. The partnership of Stead & Simpson's (boot and shoe manufactures) began back in 1834 and this would probably have been the first of the multi-national shops to arrive in Colchester. Although the shop has witnessed many changes since that time, the shop doorway mosaic serves as a nostalgic reminder of former times.

*Below:* Victorian mosaic in shop doorway.

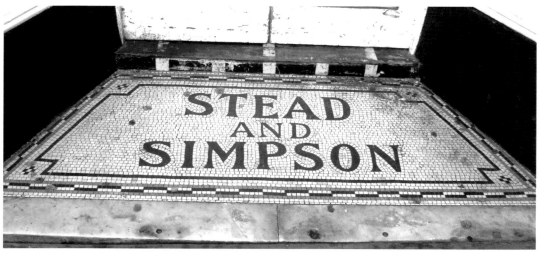

**6, 7 & 8 St Botolph's Street**
*Right*: This row of shops is
housed in a building that
would not look out of place
in the centre of the High
Street. Rising in part to four
storeys, the building has
an impressive stone façade
with a smattering of classical
features. Note in particular
the tripartite window with
attached Corinthian columns
and pediment. The centre
section, which projects
slightly from the rest of the
building, has a modillioned
cornice at fourth-floor level
with pilasters and quoins at
the edges. In July, 1889 No. 7
was acquired by the Church
of England Soldiers Institute
who later added No. 8 when it
became available. By the late
1890s much of the building
had been acquired by the
Colchester Liberal Club.

*Below:* Detail of upper
floors.

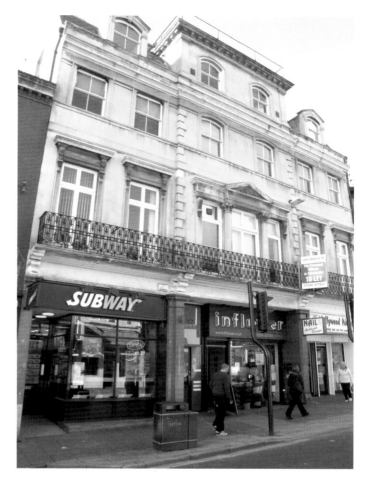

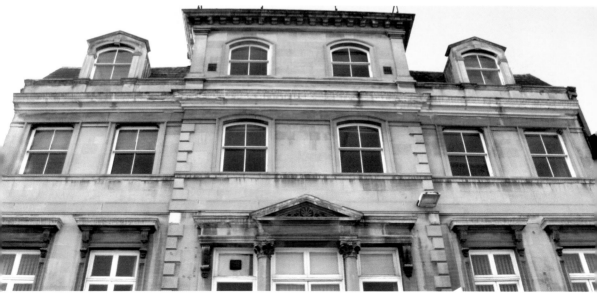

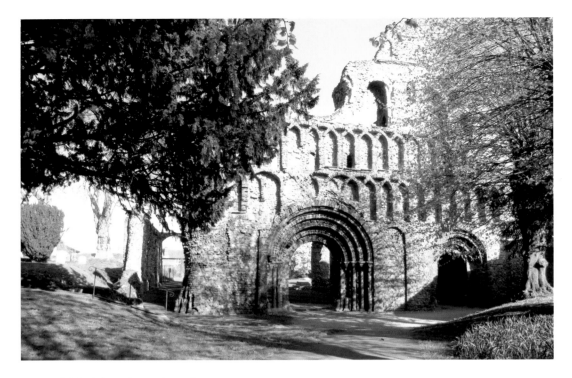

**St Botolph's Priory (West Front)**

The picturesque ruins of St Botolph's Priory are all that remain of a house of Augustinian canons founded here around the year 1100. The surviving parts of the building include a section of the west front and part of the nave. The west front is dominated by the great west door, sometimes referred to as the 'Pardon Door', where at certain times of the year the public could bring their gifts to the Priory and receive a pardon or absolution for their sins. Above the doorway is an impressive range of blind brick arcading, above which is the remains of an early round window.

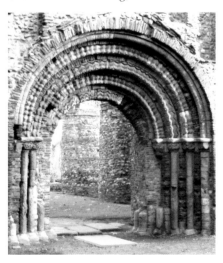

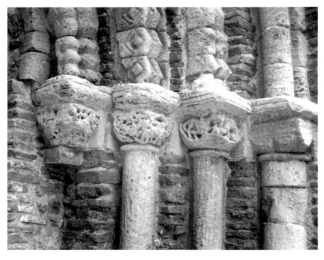

*Left*: The great west door with its impressive chevron moulding.

*Right*: Detail showing carved stonework on great west door.

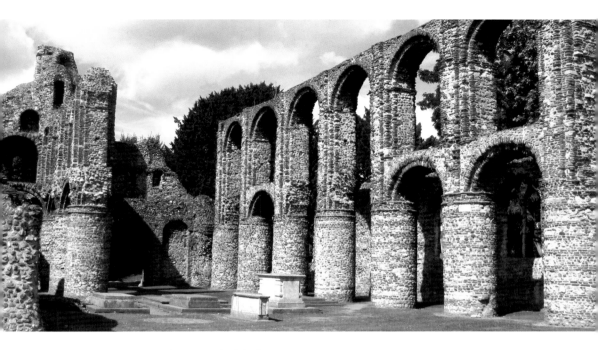

## St Botolph's Priory (Nave and Aisles)

Looking from the opposite direction we can see the impressive nave and triforium arcades, all built using recycled Roman brick and mixed rubble. There would also have been a third-storey arcade forming the clerestory, although this has not survived. Note also the large, Norman-style cylindrical columns and the plain pilasters between the arches.

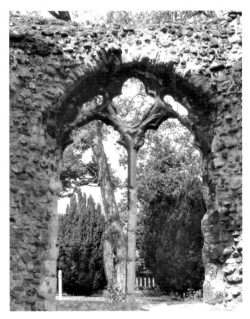

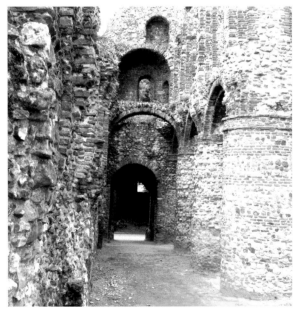

*Left*: Fourteenth-century decorated window in the north aisle.

*Right*: Looking through the south aisle towards the west front.

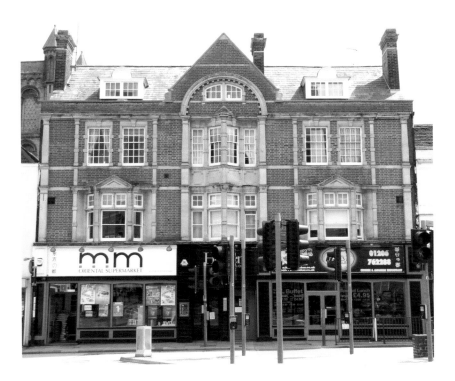

### 27–30 St Botolph's Street

This impressive red-brick building was constructed sometime around 1903–04 for A. J. Lucking & Company whose former premises on the site had been destroyed by fire in January 1903. The building is of three storeys with attic and dormers. The façade above ground floor level is a splendid mix of red brick and stone dressings, which includes a central V-shaped oriel type window rising to a modillioned semicircular pediment. On either side of this are two first-floor projecting bays with pediments. Note also the string courses and ornamental pilasters.

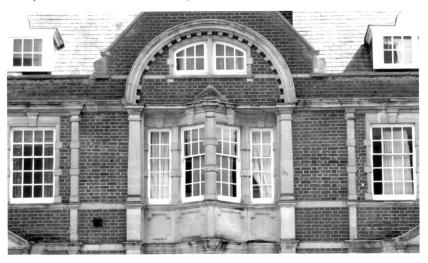

Detail of V-shaped window with semicircular pediment.

**The Judge and Jury
(St Botolph's Circus)**
Enjoying a prominent position
at St Botolph's Circus, this
recently renamed venue can
trace its history back to 1865.
It was originally known as The
Fountain and traded as both
a hotel and public house. The
building rises to three storeys
and is topped with a decorated
gable containing scalloped
barge boards. The façade and
dressings are mainly of brick,
although the use of rustication
for the quoins and at either side
of the central windows serves
to enhance its overall affect.

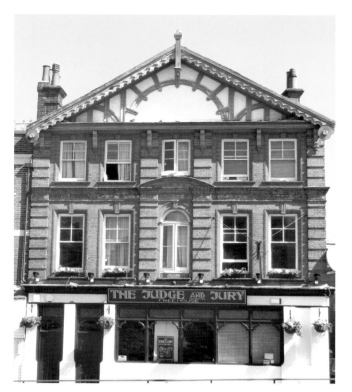

Central arched window with
segmental pediment and
rusticated brickwork.

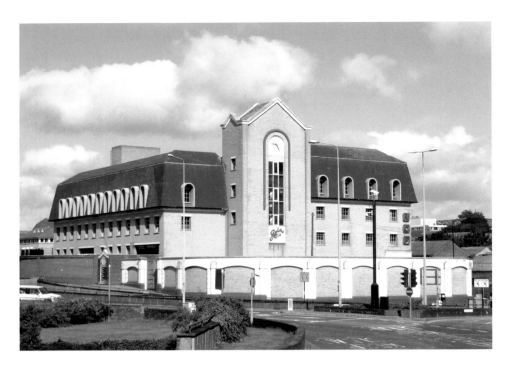

## Osborne Street Car Park

As far as modern car parks go this large NCP version on the corner of Southway and Osborne Street takes some beating. It was constructed during 1990 and despite its core concrete framework the building does exude a degree of style and elegance. The exterior of the building was designed to blend in with existing local architecture and from all angles one is treated to classical arches, Georgian-style windows and pediments. Another example of good town planning.

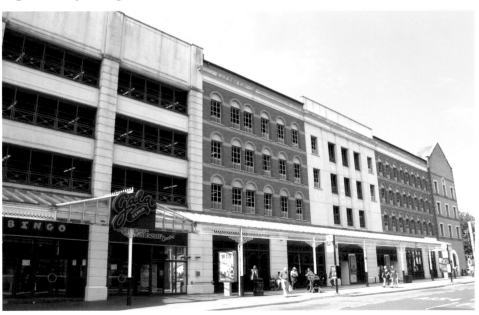

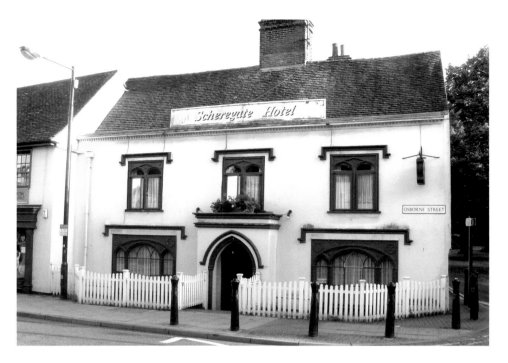

## 36 Osborne Street (Scheregate Hotel)

This timber frame and plastered house dates from the late eighteenth century and once formed part of an extensive brewery complex owned by the Barns family. In the 1830s, Richard Coleman converted the old brewery into an iron foundry and set up home in what is now the hotel building. Although the front of the building has seen some alterations over the years, it contains some interesting features in the form of a Gothic-style porch with pointed windows and hood moulds.

Part of the building as it appeared in the 1980s, with exposed timber-framing.

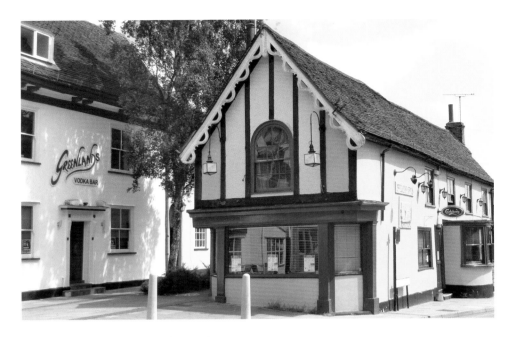

### 31 Osborne Street (Brewer's Arms)

The Brewer's Arms is another timber frame and plastered building that occupies a prominent position at the foot of Scheregate Steps. The earliest recorded date for the house is 1736 when it was known as Nutshell Hall and divided into several tenements. It was first licensed as a public house in 1805 and named the Brewer's Arms. The west end of the building has an attractive gable with decorated barge boards and an arched window. On the south wall is some modern pargetting work showing the pub and some adjacent buildings.

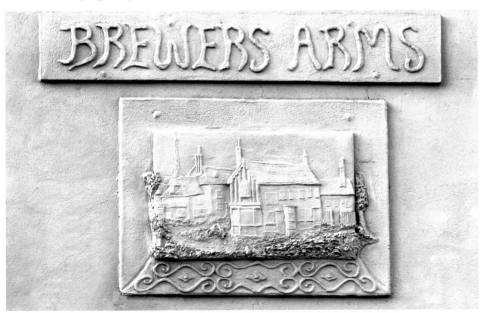

Modern pargetting work.

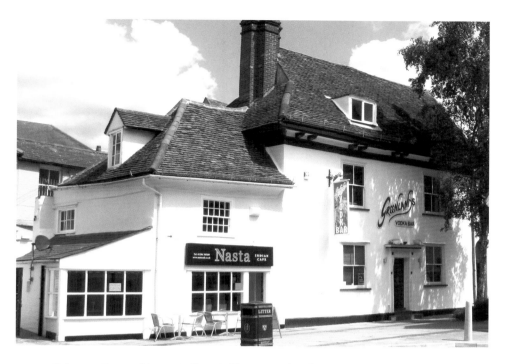

**33–34 Osborne Street (Nasta Indian Café & Greenland's Vodka Bar)**
These two pictures taken more than a hundred years apart show that very little has changed in the appearance of this property. Beneath the plastered exterior the building is of timber frame construction and dates from around the late seventeenth century. Note the interesting split-tiled roof with dormer windows and especially the overhanging eaves with moulded cornice and carved pairs of modillion brackets.

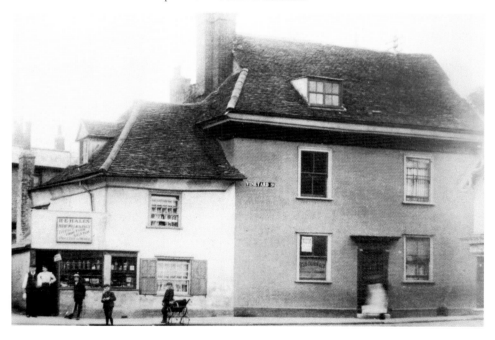

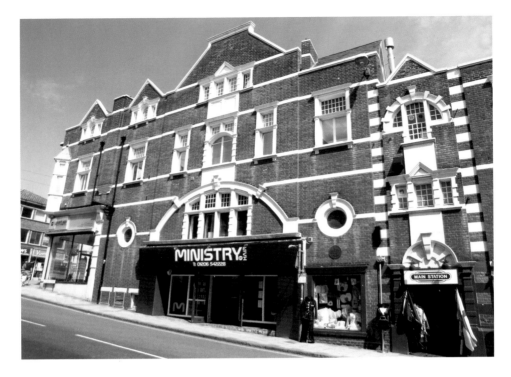

**49–53 St John's Street (Headgate Buildings)**

This is the St John's Street façade of a large corner building that continues round Headgate Corner into Sir Isaac's Walk. It was constructed in 1909 as a new home for the Liberal Club, although in 1910 part of the building was converted into the town's first cinema, known as the Headgate Electric Theatre. The building is of red brick with lavish stone dressings throughout – too much to describe in detail here. But note especially how the building is divided horizontally with a series of string courses and coping stones, and how the use of plain and rusticated pilasters has greatly enhanced the appearance of the windows.

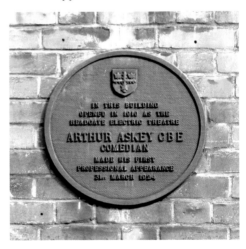

*Left*: Close up of window overlooking Headgate Corner.

*Right*: Plaque showing that comedian Arthur Askey made his stage debut here in 1924.

## 6–10 Headgate

*Right*: An imposing corner building of white brick with red brick and stone dressings. The building rises to three storeys with an attic and dormers. The ornamentation includes a modillioned cornice, the bracketing of which is imitated beneath the upper window mouldings and the sills on the north elevation. Note also the modillions above the shopfront and the slender cast-iron columns, which may be original features. Observe also that an attempt has been made to enrich the western elevation with the addition of some contemporary artwork. The eye-catching murals were completed by students from the Girls County High School during the summer of 1986.

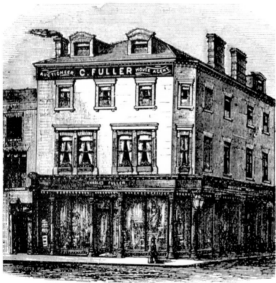

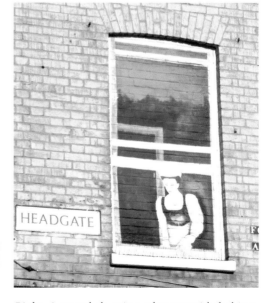

*Left:* The building as it appeared in the late 1880s.

*Right:* A mural showing a housemaid shaking a duster out of the window.

45

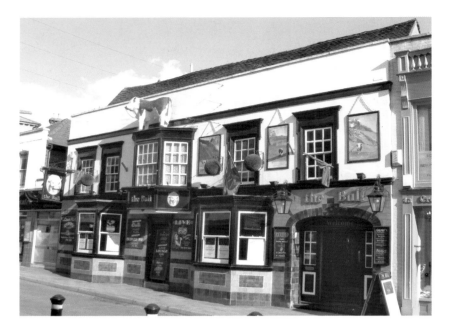

### Bull Hotel

The origins of this establishment are thought to date from the early 1400s, although most of the present structure would seem to be the result of eighteenth-century rebuilding work. There are two canted bays at the ground floor level as well as an arched carriageway. Above is an oriel bay and four other sash windows all with moulded surrounds, although some of this moulding work is a later addition. The tiling at ground floor level is also a recent embellishment. The most striking feature, however, is the large bull that now stands on top of the oriel window, providing an excellent form of advertising.

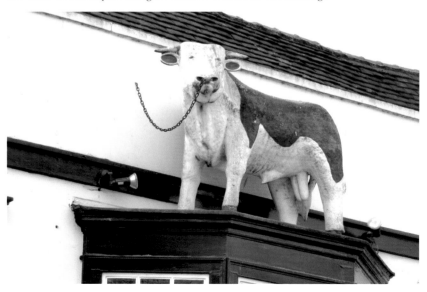

The bull mounted on the front of the building.

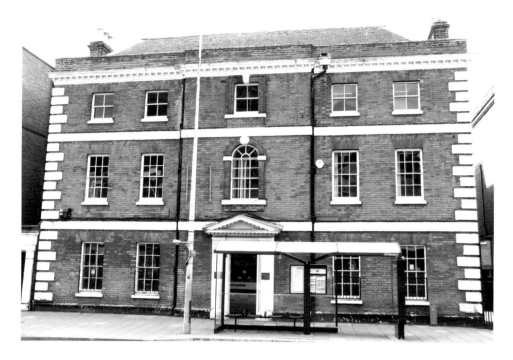

## 20–22 Crouch Street

This large red-brick building was constructed in the early 1760s for John Cole, Merchant and Gentleman. The house is of a box-shaped design with a series of three-hipped roofs running east to west. The front elevation is impressive with prominent modillioned cornice and bold painted quoins and bands. The cornice work is repeated in the pediment of the doorcase, and the arched window above stands out with its brick surround and painted stones. The remaining sash windows are fully recessed with gauged brick arches, although the upper central window has a moulded brick surround. Pity about the street furniture marring the view.

*Left*: Modillioned cornice with painted quoins and band.

*Right*: Window with moulded brick surround and painted keystone.

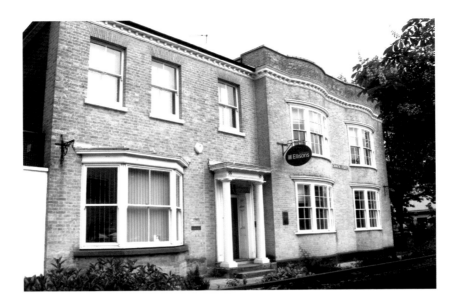

### 53–55 Crouch Street

This attractive building of gault brick would appear to date from sometime after 1790. In 1789 the building was purchased by John Killingworth Bowland, Hatter and Wine Merchant, who in 1795 sold it to John Pattrick. The description of the house in the auction details of 1789 makes no mention of it being a 'brick building', so one would assume that the house was modernised, with the addition of a brick front, sometime after this date. The façade incorporates a pair of shallow two-storey bow windows rising to a modillioned cornice and parapet. The recessed left side of the building has a Doric-style doorcase and canted bay window.

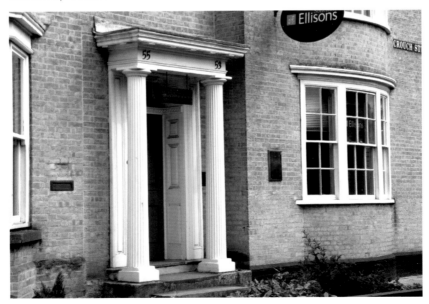

Doric-style doorcase and bow window.

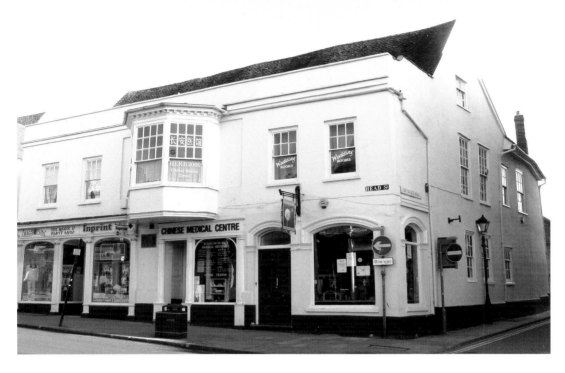

## Headgate House (Rebow's House)

This large timber frame and plastered building, standing on the corner of Head Street and Sir Isaac's Walk, dates from the 1690s and was the former home of Sir Isaac Rebow, a member of one of Colchester's wealthiest families in the seventeenth and eighteenth centuries. The house was re-fronted in the eighteenth century and provided with its distinctive oriel window.

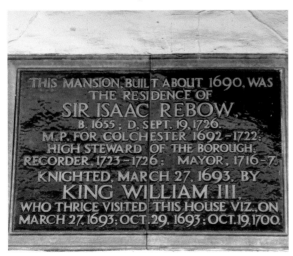

*Left*: Plaque dedicated to Sir Isaac Rebow.  *Right*: Oriel window with modillioned cornice.

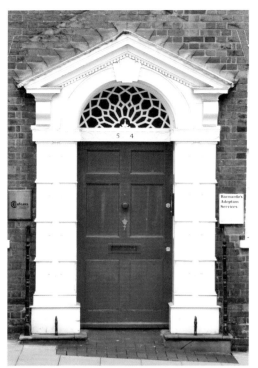

## 54 Head Street

*Below*: This is a seventeenth-century timber frame building with an added eighteenth-century brick front. During the Georgian period this house would have stood amidst a number of similar dwellings that lined the street. Below the parapet is a brick modillioned cornice and central window with painted keystone and shouldered brick architrave. The recessed sash windows have gauged brick arches, and the central doorcase has decorated pilasters with an open pediment.

*Left:* Doorcase with open pediment and decorative fanlight.

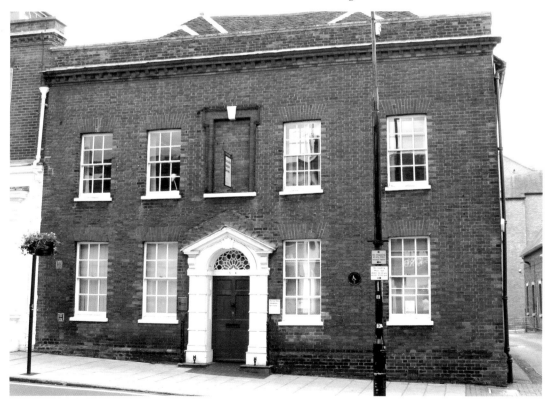

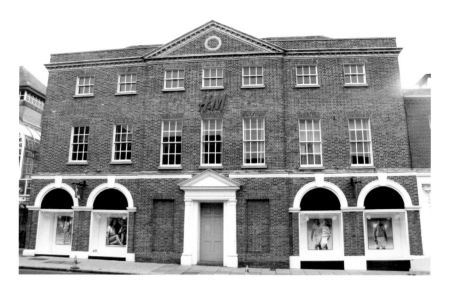

### 44–52 Head Street

In its heyday this would have been one of the grandest houses in town. Built in the 1760s for Hugh and Ann Osborn, it later became known as 'Smithies House' following its acquisition by the eminent Colchester attorney and Town Clerk Francis Smithies in 1783. By the 1980s, little of the original building had survived although it was planned to incorporate the brick front of the structure into the new shopping precinct. However, the building was found to be too unsafe and had to be completely demolished and rebuilt. Today, apart from the ground floor's arched windows and Tuscan doorcase, which were not original features, the restored façade retains much of its original character.

The building in its original form, showing a central doorcase with Ionic columns.

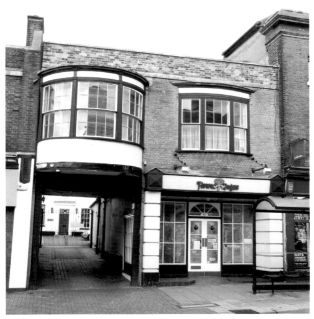

## 41 Head Street

*Left*: This is all that survives of a large grey brick fronted house that stood over the entrance to the old King's Head inn courtyard. The missing section of the building to the left was removed in the 1930s to make way for a new group of shops. Above the carriageway leading to the courtyard is a bow-shaped oriel, with a shallower version to the right. This latter bow window originally rose from the ground floor before the lower part was replaced with a new shopfront. The stone string course running above the upper windows would originally have continued across the front of the building.

*Below:* The building as it appeared in the 1880s.

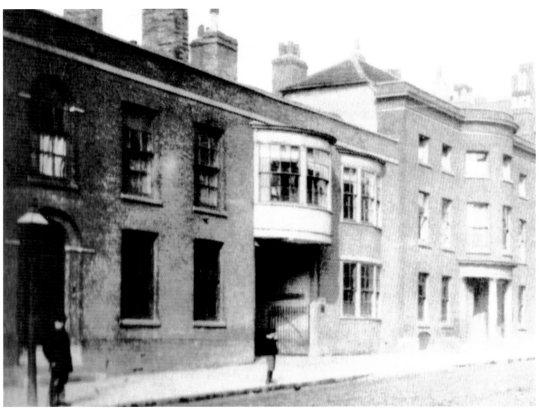

### 37–39 Head Street

*Below*: In the late eighteenth century this large brick-fronted house was home to James Buxton, Wine Merchant and Distiller. The brick front covers an earlier timber frame building and is rather unusual in that the semicircular Doric porch is supporting a two-storey bow window. This is a similar layout to that already seen at the Minories (see p. 22). Note also the parapet, which continues round the bay, and the ornamental brick string course below.

*Right:* Roman Doric porch featuring typical triglyphs in the frieze. Note also the arched doorway and fanlight.

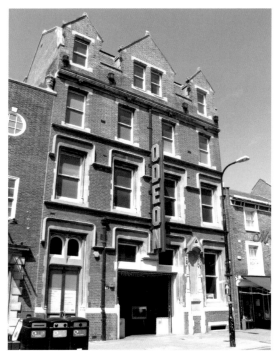

## 29–31 Head Street (Odeon Cinema)

*Left*: The façade of this high-rise Victorian structure is all that remains of the old post office building which opened on 22 June 1874. At the time it was the tallest building in Colchester and in 2002 it was incorporated into a new Odeon cinema. The red-brick façade is broken up with stone dressings, including moulded string courses and linked hood moulds. Note the Gothic-style niche to the right of the doorway, which formerly housed a clock that was set to Greenwich or Railway time. In those days local time could vary by several minutes from one clock to the next.

*Below left:* The Gothic-style niche minus its clock.

*Below right:* This view from 1887 shows the niche with the clock *in situ.*

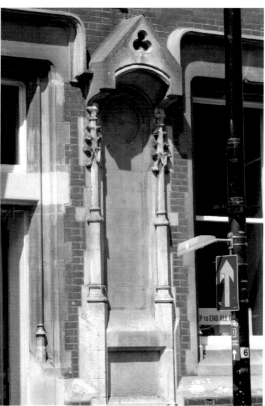

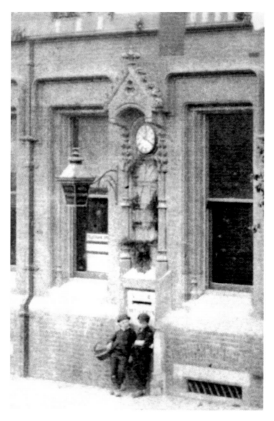

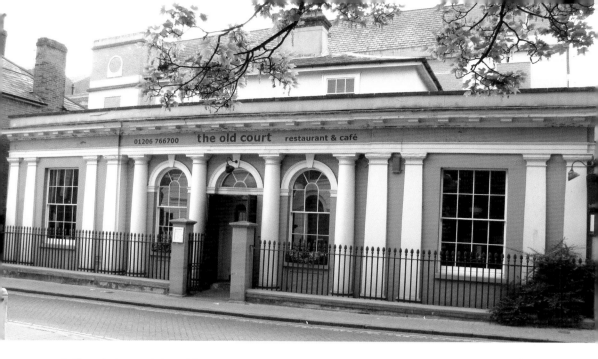

### 8 Church Street (The Old Court Restaurant and Café)

This attractive classical-style building formerly housed the offices of the local County Court and was built in the early 1800s. The entrance takes the form of a shallow tetrastyle portico with columns and pilasters following the Roman Doric order. Above the plain architrave and frieze is a heavy cornice with plain stone modillions.

Roman Doric capital.

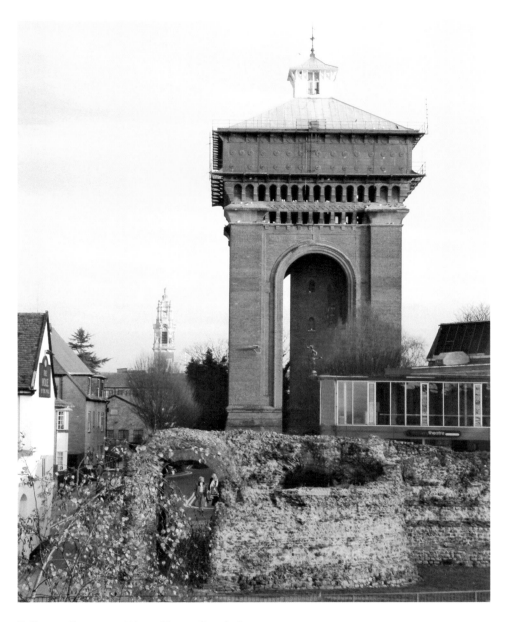

### Balkerne Passage – Water Tower (Jumbo)

This large Victorian water tower, nicknamed Jumbo, bears the date 1882 and was dedicated for public use on 27 September 1883. It is one of the few surviving local examples of industrial architecture from the period and is a Grade II* listed building. Some 1.2 million bricks were used in its construction along with 400 tons of cement. The specification further required that each brick was able to resist, without fracture, a crushing weight of 25 tons. In fact, the whole structure would have needed to support a load of nearly 1,500 tons with the tank full of water. The large brick outer piers are connected by four tall Roman-style arches, a feature in keeping with the nearby Roman gateway. The tower supports a large cast-iron tank with a capacity of 221,000 gallons when full. The water tower was decommissioned and sold to a property developer in 1987.

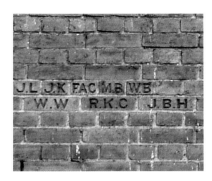

**Water Tower (Jumbo)**

*Above*: About 30 feet up from the base of the south-west pier can be seen fifteen commemorative bricks (eight pictured) bearing the initials of members of the Waterworks Committee of 1882. Note also the English bond brickwork.

*Right:* The rooftop tower room with weather vane featuring Jumbo the zoo elephant.

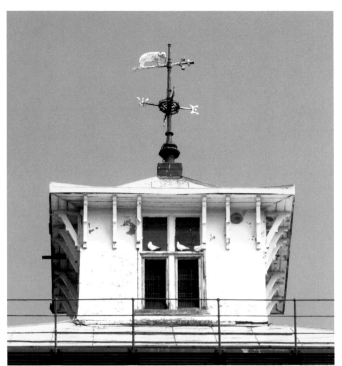

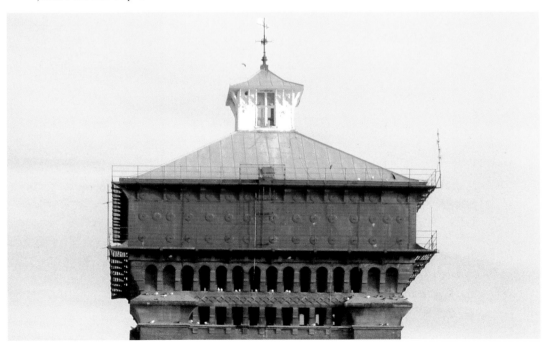

The 12-foot-deep tank is made up of cast-iron plates and is supported on cast-iron girders resting on granite supports. The pyramid-shaped roof is covered with rolled sheet copper and capped with a rooftop viewing room.

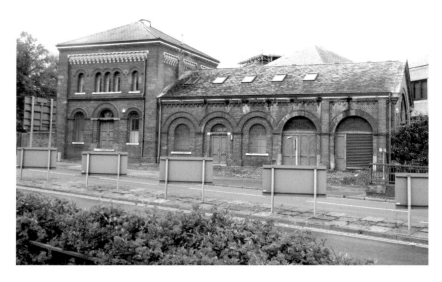

## Balkerne Hill (Water Pumping Station)

This is another industrial heritage site from the late Victorian period, which follows a similar Roman style to that of the water tower which it served. It comprises a two-storey block with basement and a single-storey machinery room, both in red brick with stone dressings. The machinery room has a range of five gauged brick arches, above which is a decorative moulded brick cornice with modillions. The two-storey block contains a number of casement windows, all set within Roman-style gauged brick arches and hood moulds. The south elevation of this block is separated into three bays by two full height pilasters and the three twin-arched windows at first floor level each lie beneath a decorative machicolated stone cornice.

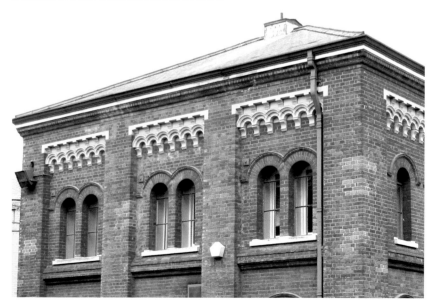

Triple twin-arched windows with ornamental stone corbelled arches.

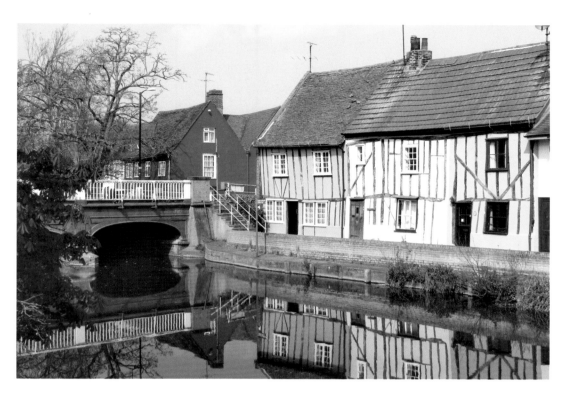

## Riverside Cottages

These picturesque seventeenth-century timber frame cottages enjoy a near perfect setting overlooking the River Colne. In 1903–04, the three-span cast-iron bridge, which dates from 1843, was widened by 17 feet 6 inches on its eastern side in order to accommodate the new tramway system. In so doing, however, the corner riverside cottage had to be demolished.

*Left*: View showing Riverside Walk and cottages in 1880. Note the corner cottage still standing at the end of the row.

*Right*: View showing the end cottage before demolition and bridge widening.

## 19–20 North Hill

The large copper kettle hanging over the front of this building serves as a reminder to its former use as an ironmongery shop. The earliest ironmonger recorded here was William Bultitude who traded between 1863 and 1901, at which time the business was taken up by Thomas Evans. The Evans family continued trading until 1991. The building is of timber frame construction with a brick front added in the eighteenth century. The ground floor is given over to shopfronts and a carriageway, but the upper floor still retains much of its Georgian character, including the high parapet with coping stones, the brick and stone string courses and the Venetian window. Note also the fire mark fixed at high level.

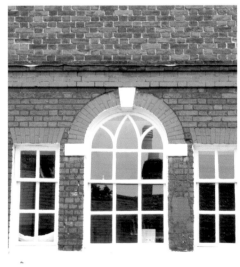

*Left*: Sun Insurance Company fire mark.       *Right*: Venetian window with stone dressings.

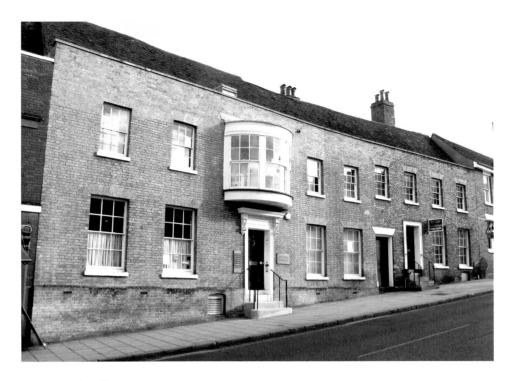

### 17–18 North Hill

This sixteenth-century timber frame building had been modernised with the addition of a grey-brick front by the early 1800s. This brick frontage rises to a parapet with coping stones and one can just see a small square dormer in the attic. There is a range of eight standard sash windows with gauged brick arches, although the most eye-catching feature is the bow-shaped oriel overhanging the doorcase of No. 18.

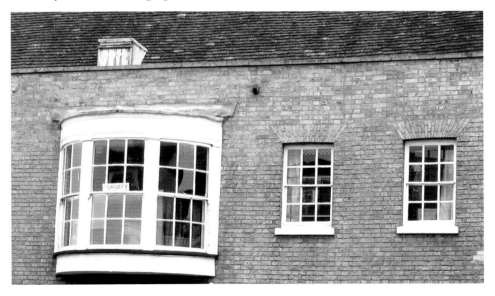

Oriel window alongside recessed sash windows.

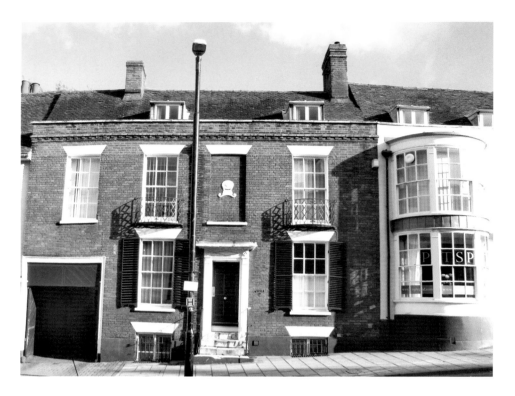

### 5–6 North Hill

This was the home of Joseph Wallis Jnr, whose father had set up an iron foundry on the north side of High Street in 1792. The dated wall plate would suggest a building date of 1809 – at least for that of the brick front. The building is of two storeys with attic and dormers and below the parapet is a dentiled brick cornice. Of particular interest are the decorated cast-iron lintel plates fitted above the sash windows, and the two semicircular iron balconies fitted at first-floor level. Note also the distinctive two-storey bow window on the building adjacent.

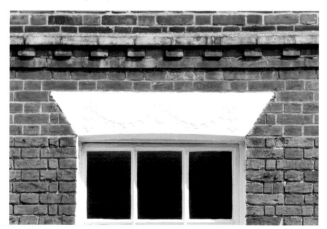

*Left*: Decorated cast-iron lintel beneath cornice.

*Right*: Dated wall plate fixed to blind upper window.

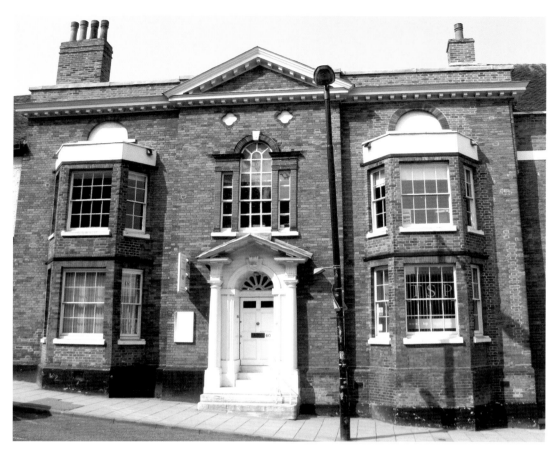

## 60 North Hill

*Above:* This grand looking building is thought to date from 1650, although the brick front is later. Prior to 1775, this was the home of Isaac Boggis, of the well-known family of Colchester baymakers, before he moved across town to East Hill. The building rises to two storeys and incorporates a pair of full-size canted bays, set either side of the slightly projecting central front with doorcase and Venetian window. The doorcase, with open pediment, has clear Tuscan features in the column detail, although the triglyphs in the frieze area are Doric.

*Right:* Tuscan/Doric doorcase with open pediment and fanlight.

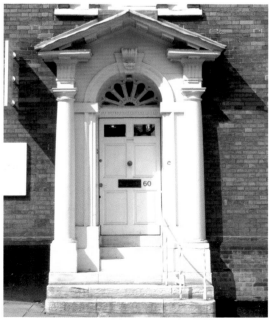

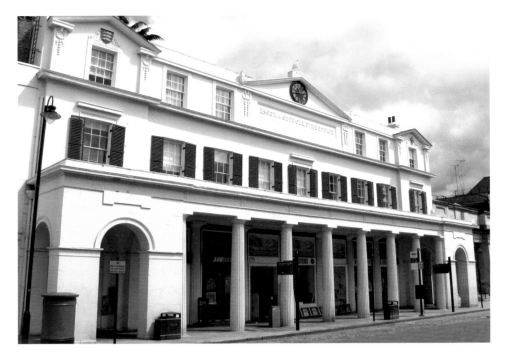

## 157 High Street (Fire Office)

This imposing structure standing at the west end of High Street was opened in 1820 as a dual-purpose building. The ground floor was used as a Corn Exchange whilst the upper floor housed the offices of the Essex & Suffolk Equitable Insurance Society (a third storey was added *c.* 1915). The double colonnade of Greek Doric fluted columns are of cast iron and were probably manufactured at Wallis's nearby foundry (see p. 62). Much of the building is also clad in sheets of cast iron – a useful deterrent against fire! Modern shopfronts have replaced the original market area.

*Left*: Colonnade with modern shopfronts.

*Right*: Greek Doric capital with triglyph in the frieze above.

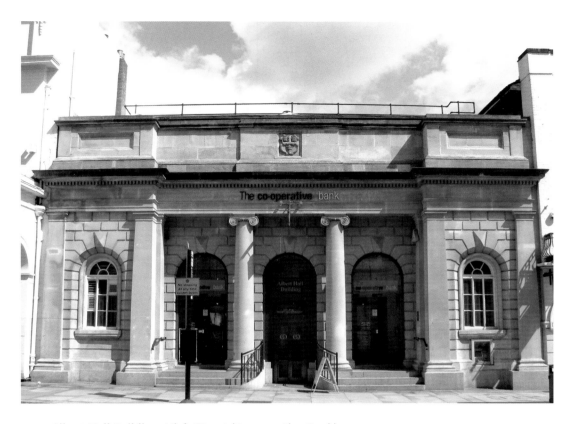

## Albert Hall Building, High Street (Co-operative Bank)

This sandstone-fronted building began life as a Corn Exchange in 1845. It was later used as a school of art and science, an art gallery, a theatre and more recently a branch of the Co-operative Bank. The entrance is in the form of a shallow portico containing two Ionic columns *in antis*. The side windows, with rusticated surrounds, were originally niches containing full-sized female statues (now to be seen outside St Mary's car park, Balkerne Way). A statue of Britannia also once adorned the top of the building.

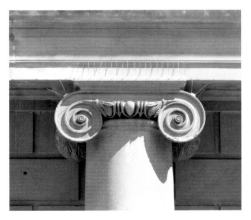

*Left*: Ionic capital with volutes and egg and dart decoration.

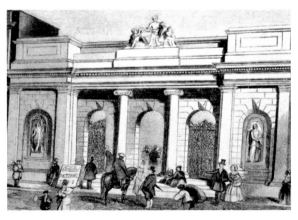

*Right*: The building as it once appeared with statues *in situ*.

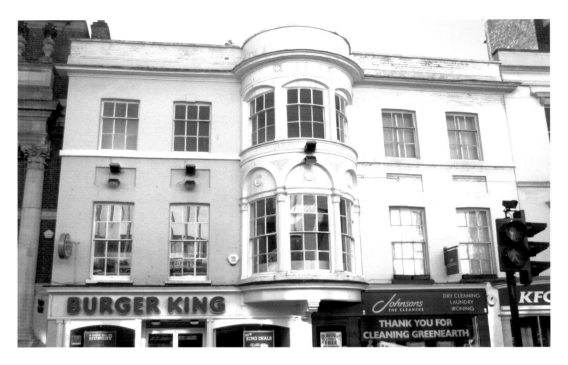

**11a–11b High Street**

This impressive bow-fronted building dates from the eighteenth century when its grand façade was added to an earlier building. From at least 1764, Samuel Carr had established a grocery business here. The Carr family were still trading in the 1851 census, but by 1861 the shop had passed to Frederick Phillips, who was employing seven assistants, three of whom were living on the premises. The most striking feature of the building today is its double-storey oriel window with its prominent moulded cornice and other decorations.

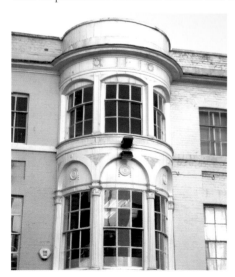

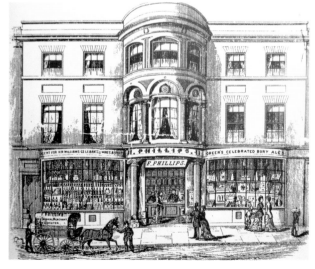

*Left*: Two-storey oriel with classical columns and other decorative features.

*Right*: The shopfront in the 1860s with its classical entrance and ground floor bow windows.

**12 High Street (Waterstones)**

*Right*: This is a good Neo-Classical shopfront, which opened as a branch of the National Provincial Bank in April 1925. The building is of red brick and stone and features three tall arched openings, with casement windows above, each framed within a series of giant attached Corinthian columns. The columns are supporting a plain entablature with balustrade topped with ornamental urns.

*Below left:* Corinthian capital with acanthus leaf decoration.

*Below right:* Detail showing column heads and balustrading.

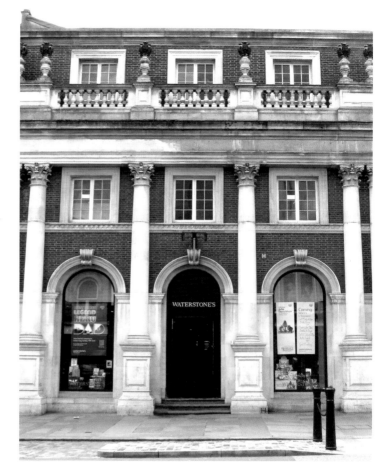

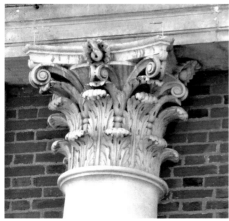

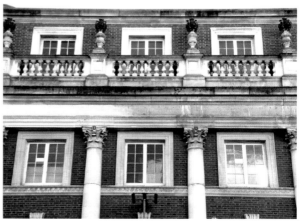

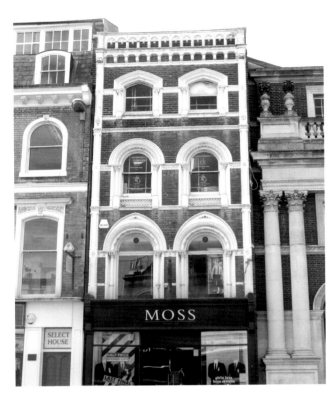

### 14 High Street (Moss Menswear)

*Left*: Here is good example of High Victorian architecture with its bold combination of revival styles. The present frontage, above ground floor level, dates from 1867 when rebuilding work took place following a major fire. The building rises to four storeys with the windows above ground floor level paired in alternating styles, all with enriched mouldings and colonnettes. At roof level is a prominent corbelled cornice and arcaded parapet. From 1895 until the early 1990s, the building was occupied by Owen Ward, tailor and outfitter.

*Below:* Top-floor window detail with cornice and parapet.

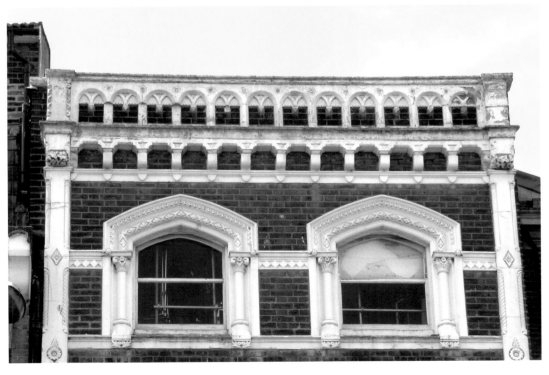

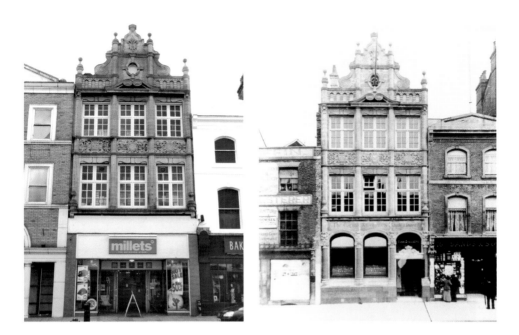

## 17–18 High Street (Millets)

*Above left*: This is another building that began life as a bank and was known as the Capital & Counties Bank Limited. Above the ground floor shopfront, added by W. H. Smith & Son in the late 1920s, the building retains its original stonework and decorations. Between the first and second floor levels are some ornamental panels with strapwork decoration that includes a building date of 1901. The building then rises to an arcaded parapet set within an elaborate scrolled pediment and finials.

*Above right*: The original building as seen in the early 1900s.

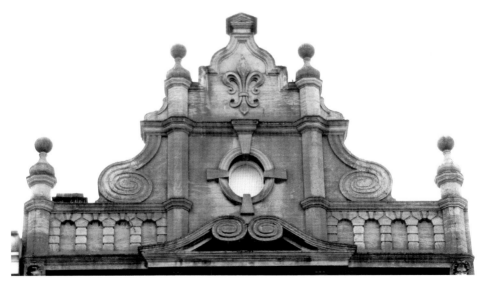

Ornamental scrolled pediment.

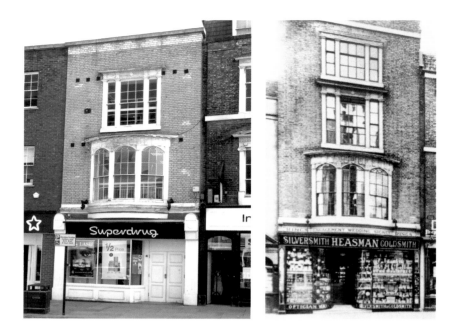

**22 High Street**

*Above left*: This late eighteenth-century bow-fronted building was originally four storeys in height. The top floor, which contained a smaller version of the existing third-storey window, was removed along with the parapet in 1947. Until the 1960s, the shop was in the occupation of Heasman & Son, a well-known local jeweller and silversmith, whose family began trading here in 1892. In fact, there has been a silversmith trading from these premises since at least 1835.

*Above right:* The building as it appeared in the 1930s.

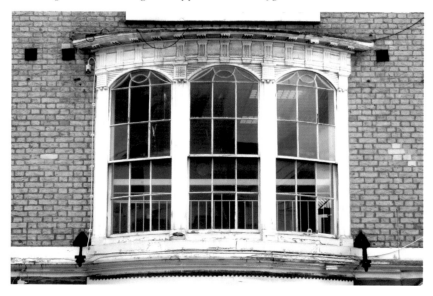

First-floor bow window with Doric-style frieze.

## 25 High Street (NatWest Bank)

*Right*: This early example of Edwardian 'Free-style' architecture opened as the London & County Banking Company on 29 October 1903. It was built by Messrs Grimwood & Sons of Sudbury at a cost of £8,814, and following a series of mergers later became known as the Westminster Bank. The partly rusticated ground floor gives way to a bold façade with alternating light and dark stone bands crossing through the upper bays. The decorative central panelling is eye-catching and is further enriched by a deep modillioned cornice and ornately carved central console.

*Below:* Carved panelling and decorated cornice.

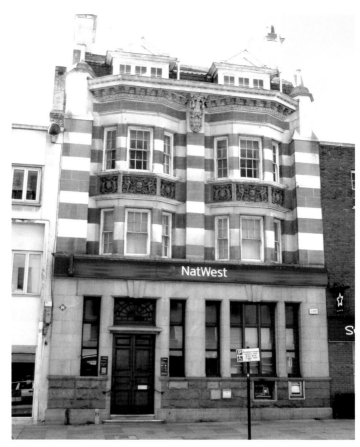

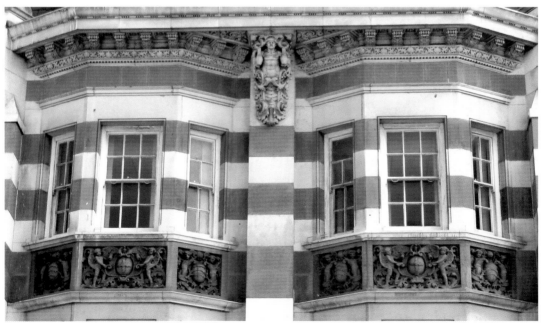

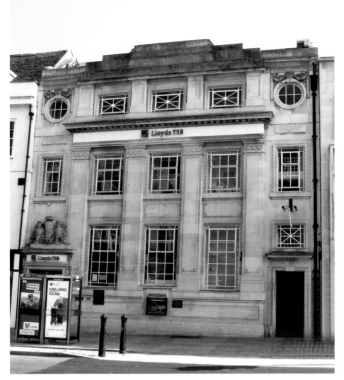

**27 High Street (Lloyds TSB Bank)**

*Left*: A 1920s stone-fronted building with classical features. The two side entrances nicely frame the three centre bays, which are divided by giant pilasters rising to a dentiled cornice. Note also the decorated small circular windows and the cartouche flanked by putti over the left side entrance.

*Below:* Cartouche bearing the Bank's rearing horse symbol and foundation date.

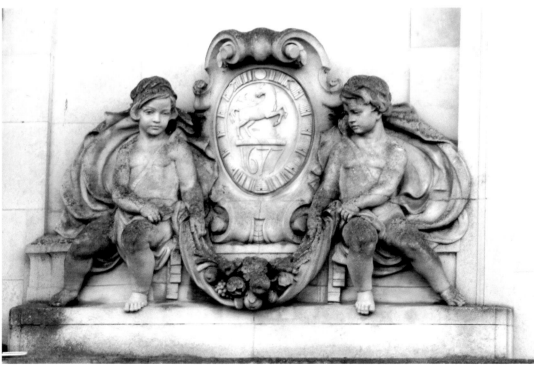

## 35–37 High Street (McDonald's Restaurant)

The panel in the centre of the large oriel window gives a building date of 1879, an act precipitated by a major fire that destroyed the previous building in February 1878. Interestingly, the present structure is a modern rebuild of 1983, which faithfully mirrored much of the original design, albeit without the uppermost storey. The initials F. J. N, seen at the top of the oriel are those of former owner Frederick Noone. In 1901, the shop came into the occupation of Harry Loomes, a well-known draper, and later that of Arthur Piper and Co. This is another example of High Victorian architecture at its best.

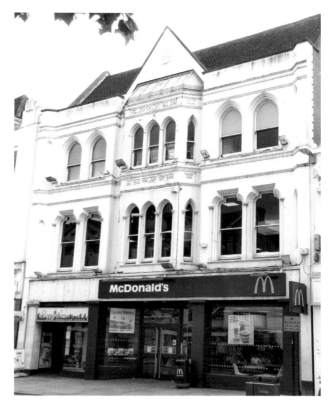

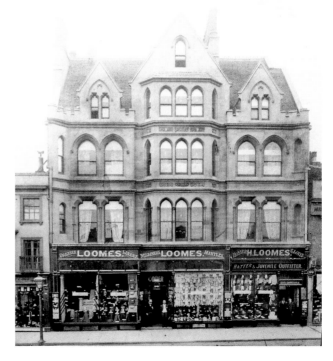

The building as it appeared in the early 1900s.

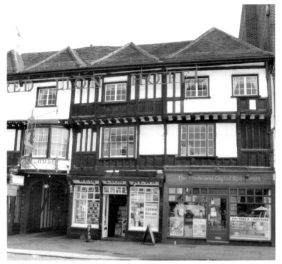

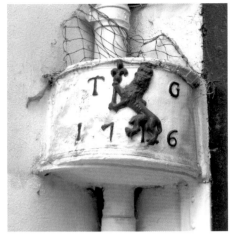

Rainwater head dated 1716.

### 42–44 High Street (Red Lion Hotel)

This is one of the oldest buildings in the High Street and is thought to date from the fifteenth century, when it was home to the Howard family, later Dukes of Norfolk. By the early 1500s, it had become an inn known as the White Lion, or simply the 'Lyon' before becoming the Red Lion. This part of the building rises to three levels with a jettied upper storey and overhanging eaves. Note the traceried panel work running along the face of the upper storeys, and also the intricate wood carving around the carriageway, including that of St George and the Dragon.

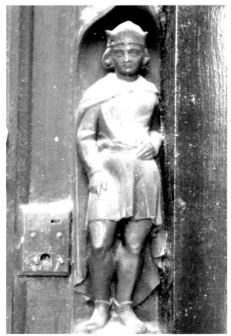

*Left*: Courtyard shop with jettied upper storey.

*Right*: Carved figure beside entranceway.

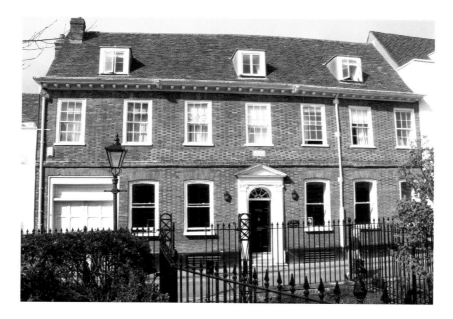

### 6 Trinity Street (John Wilbye's House)

This attractive brick-fronted house, with chequered brickwork, dates from the early eighteenth century and was a remodelling of an earlier structure. The original building was once home to madrigal composer John Wilbye (1574–1638), who spent the last twelve years of his life here. Beneath the attic storey and bold modillioned cornice, the first-floor sash windows sit beneath flat gauged brick arches, whereas those at ground floor level have segmental heads. The doorcase, with its Ionic pilasters and decorative batwing fanlight, is of late eighteenth century style and was probably a later addition.

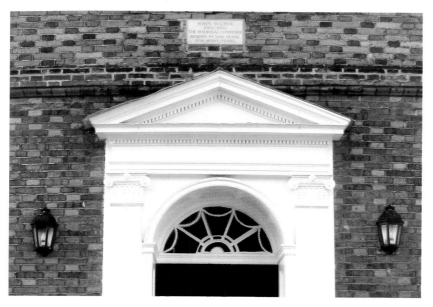

Upper part of doorcase with dentiled pediment and decorative fanlight.

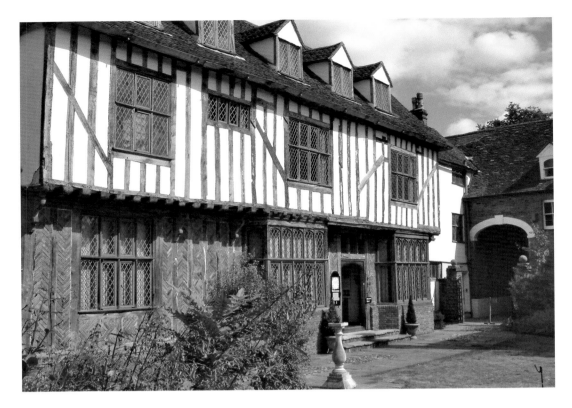

### 8 Trinity Street (Tymperleys)

What is today known as 'Tymperleys' is part of what was once a much larger building that abutted directly onto Trinity Street. It was once home to Dr William Gilberd, eminent physician and scientist, who was born here in 1544. The building is of timber-frame construction and dates from the late fifteenth century. The exterior plasterwork has been removed to expose the timber-framing, which at ground floor level is in-filled with brick nogging. The building in its present condition is the result of extensive alterations carried out in the 1950s.

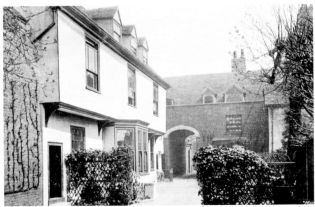

*Left*: Small projecting upper window, which may once have been a door with external staircase.

*Right*: Tymperleys as it appeared *c.* 1910.

**60 High Street (Sky Rooms Nightclub)**
An impressive red-brick corner building that opened as a branch of Parr's Bank on 25 September 1899. The building rises to four storeys where two small oriels are tucked beneath the corner gable ends. Other oriels are located further down on both frontages, including one at the corner over the door. As can be seen from the picture of the building when it was a bank, the original corner window was much larger and designed in the form of a projecting turret.

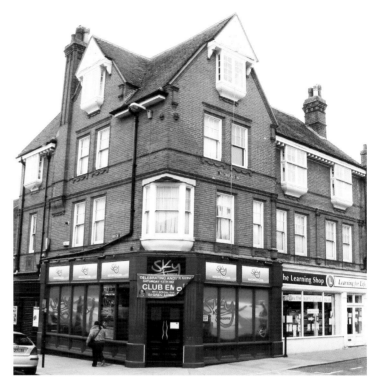

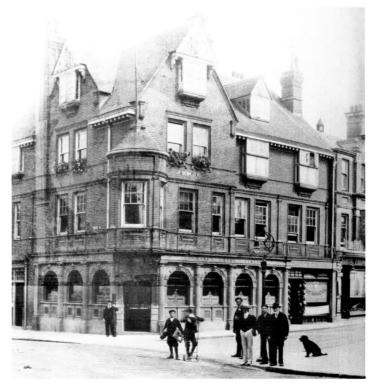

Parr's Bank in the early 1900s.

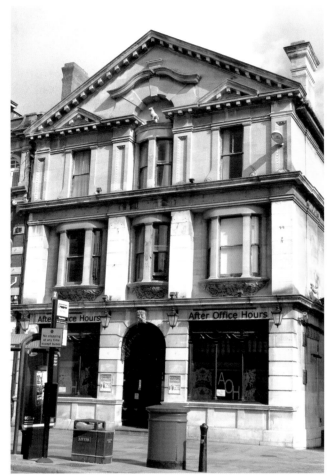

### 128 High Street (After Office Hours)

This stone-fronted Edwardian public house opened in 1904 as the Lamb Hotel, replacing a previous version which stood just a few feet away on the site of the new Grand Theatre. Its Baroque-style façade rises three storeys to a large broken pediment which spans the entire building. Each storey adds something new to the façade, from the rusticated arched entrance, with exaggerated keystone in the shape of a human head, to the middle storey with its oriels and foliated brackets, and finally to the high-level modillioned pediments with the centrally placed statue of a lamb.

*Left*: Stone statue of a lamb in high arched recess.

*Right*: The mascaron-style keystone above the ground floor entrance.

**131 High Street (Liquid & Envy Nightclub)**
*Right*: Here is another example of flamboyant Edwardian Baroque in the form of this early twentieth-century theatre turned music hall. At its height, the venue (known as the Hippodrome) was performing to packed houses twice-nightly, featuring such Vaudeville stars as Marie Lloyd and Vester Tilley, with the audiences enjoying a good old sing song. Architecturally, the asymmetrical façade is full of embellishments including alternating brick and stone pilasters with Ionic capitals, arched windows, broken cornices and other elaborate decoration, all of which is capped with a large segmental pediment containing the name Grand Theatre.

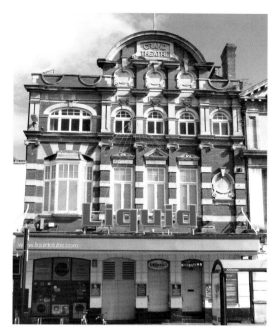

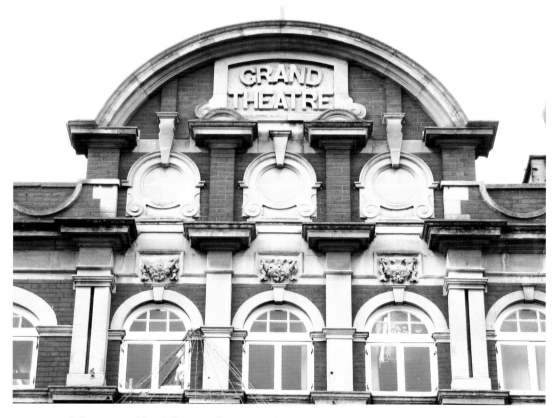

Detail showing red-brick front with stone and stucco dressings.

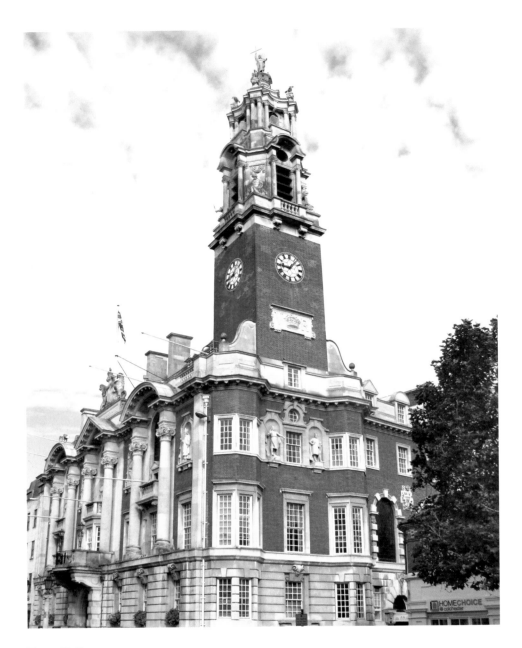

### Town Hall

By far the grandest building in the High Street is the late Victorian Town Hall, which must surely rank as one of the best examples of Neo-Baroque architecture of the period. Built of red brick and Portland stone, the building rises to 162 feet where it is crowned with a bronze statue of St Helena, the town's patron saint. Both frontages of the building are rich in embellishments which include six full-sized marble statues representing famous people from the town's past, and a row of mascaron-style keystones above the ground floor windows. The ornamentation on the clock tower is equally impressive and includes four stone statues representing the town's main industries, and four bronze ravens that are symbolic of the Port of Colchester.

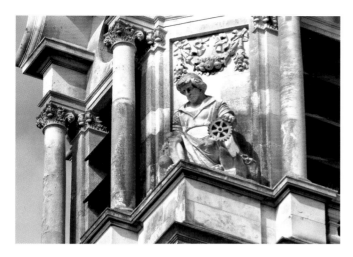

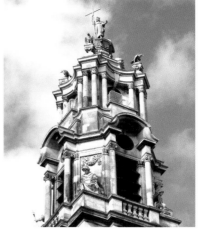

**Town Hall**

*Above left*: One of the stone figures on the clock tower depicting the town's four main industries – in this case engineering.

*Above right:* The summit of the clock tower, showing the statue of St Helena, the bronze ravens and the stone figures depicting the town's industries.

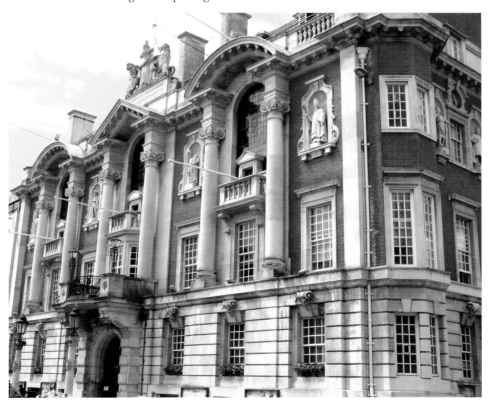

The ornate High Street façade with richly carved statues and other embellishments.

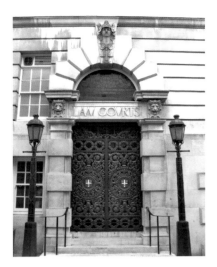 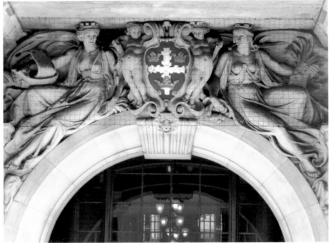

## Town Hall

*Above left*: The rusticated entrance to the Law Courts in West Stockwell Street showing the Gibbs-style surround with added embellishments. The gates were recycled from the previous Town Hall of 1845.

*Above right*: An interesting carved sculpture above the main entrance showing the post-Reformation Borough Arms supported by putti and flanked by two female figures depicting the sea and the earth.

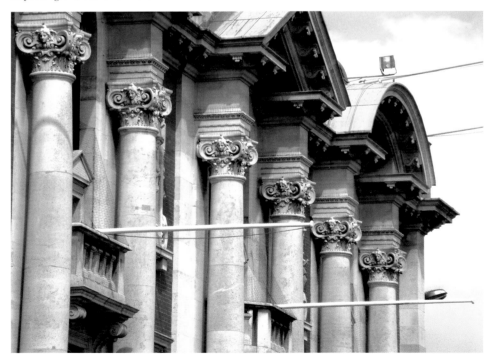

Detail showing row of columns with stylized Composite capitals.

**West Stockwell Street (Former Public Library)**
*Right*: Although now part of the present Town Hall complex, this interesting red-brick building was formerly a public library, which opened in 1894. It is Jacobean in style with an ornamental gabled façade and large square-headed windows. Note in particular the tall oriel window to provide light to the library reading room, and the open pediment within the decorated gable, supported by a pair of half-human figures projecting from splayed pedestals.

*Below:* Gable end showing the Borough Arms and Flemish-style strapwork.

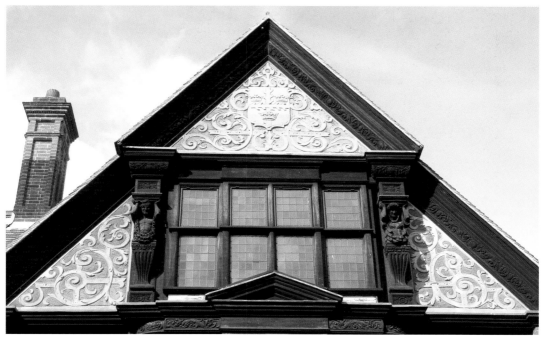

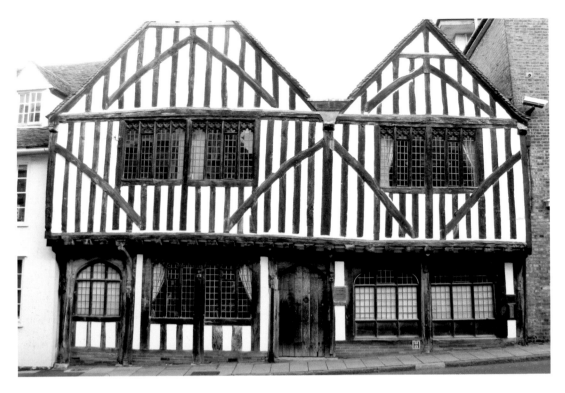

### 3 West Stockwell Street (Sparling, Benham & Brough)

An important late-fifteenth-century timber frame building with exposed close studding and some remarkable wood carving. The building has been heavily restored, but retains some interesting original features. The door to the 'screens passage' can be seen to the left of the building (north side), which would have provided access to the hall and rear of the property. The projecting upper storey is supported on carved brackets that spring from shafts with angelic style capitals. Note also the traceried heads of the windows, some of which are original.

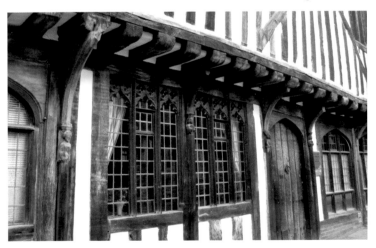

*Left*: Ground floor detail beneath projecting upper storey.

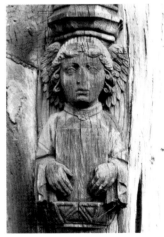

*Right*: Angel carving at front of building.

## 8–9 West Stockwell Street

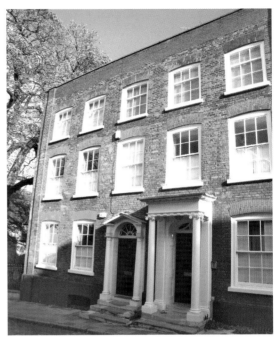

*Right*: This pair of early Georgian townhouses would appear to have once been a single dwelling which was later subdivided, probably sometime after 1802, and provided with an additional doorcase. The nearly flush-fitting windows, with exposed sash boxes, have segmental gauged brick arches, and the doorcases are distinctive for their differing appearance. The smaller one to the left has Roman Doric-style attached columns with an open pediment and fanlight, whilst its larger neighbour has detached Ionic columns and a flat entablature.

*Below:* Different doorcases may also suggest a differing social status of the occupants!

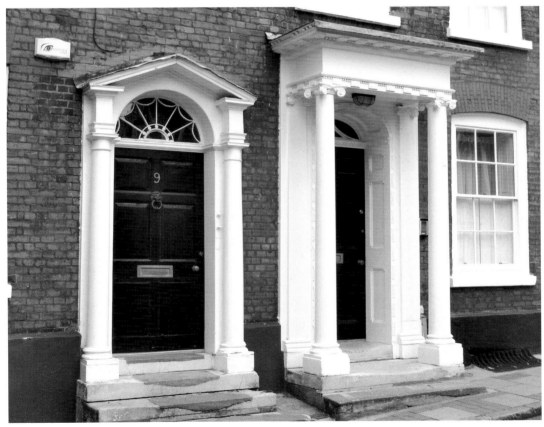

**63 West Stockwell Street (St Martin's House)**

*Below*: St Martin's House was built *c.* 1733 for Dr Richard Daniell to a design by James Deane. At first glance, the building appears to be a little unbalanced as a result of a nineteenth-century extension added to its left side, and the recessed sash windows do look as though they belong to a later period than the 1730s – perhaps altered when the side extension was added. Points of interest include the wide overhanging cornice, the grey brick panelled parapet and the bold painted keystones. Note also the Gibbs-style surround to the doorcase and the shouldered brick architrave to the window above.

*Left:* Rusticated Gibbs-style surround to doorcase.

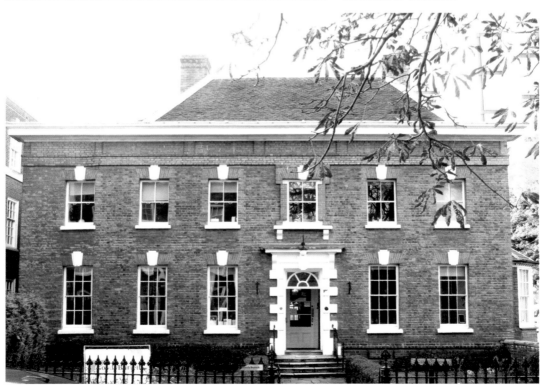

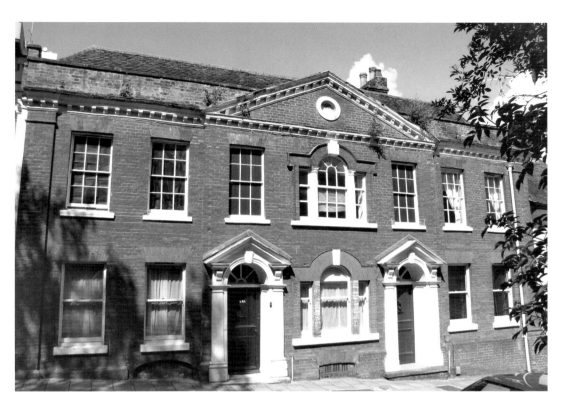

**59–60 West Stockwell Street**

*Above*: This handsome Georgian 'double house', with a single central pediment, is thought to have been built in the 1760s by Samuel Wall (1712–82). Whether the house was built as a 'double house' from the outset, or was later divided is not clear, although a deed of 1871 does tend to suggest that a division of the house may have taken place around the 1860s. The red-brick front, which is topped with a parapet, has a modillioned pediment and cornice, beneath which are two central Venetian windows, one above the other. The upper Venetian has Doric columns with a brick hood mould, while the lower version is of plain brick.

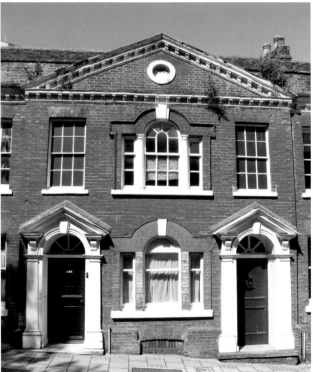

*Right:* Central section showing Venetian windows and identical doorcases.

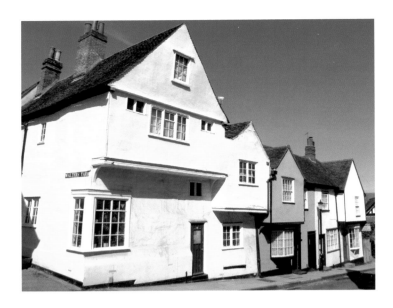

### 56 West Stockwell Street

A picturesque group of timber frame houses dating from the fifteenth and sixteenth centuries. The older of the buildings are those seen to the right of the picture with the projecting gables. Restoration work on these houses during the 1950s included the rebuilding of the lower gable. The house in the foreground, which stands on the corner of Walter's Yard, has two gables facing the street, and a jettied upper storey that takes a sharp step downhill. Note also the moulded bressumer on the main wing.

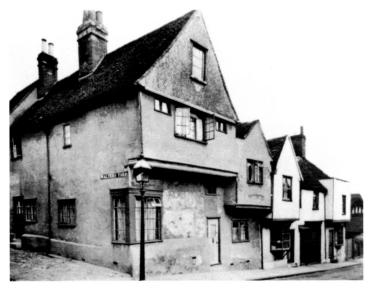

This view of the same buildings from *c.* 1950 shows that little has changed over the intervening years, except for the missing gable to the far right.

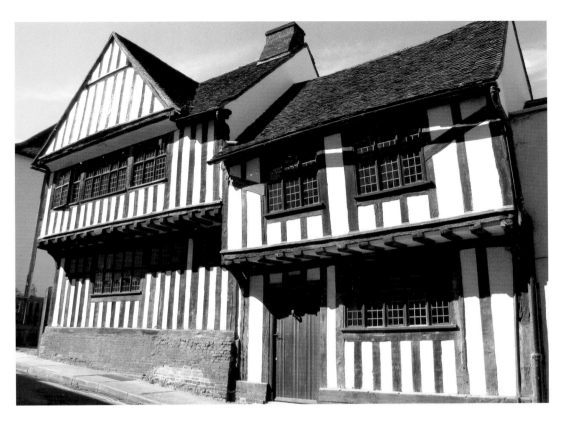

### 30 East Stockwell Street (Peake's House)

This is one of the oldest houses in the Dutch Quarter with parts of the building dating back more than 600 years. The oldest part relates to the block on the left, which still has traces of a late fourteenth-century hall, although most of the structure that we see today is from the sixteenth century. Note the jettied upper storeys and the moulded bressumer on the gable. The house was restored in 1935, and in 1946 presented to the town by Mr W. Peake (owner of a local clothing factory). The house is currently leased to the Landmark Trust.

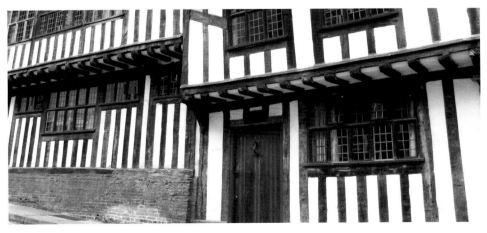

Exposed timber-framing and brick plinth.

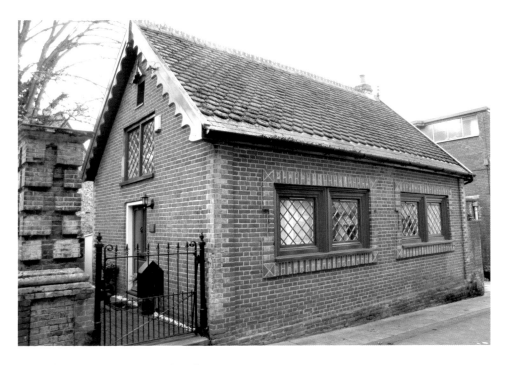

## Old School House, East Stockwell Street

It seems hard to believe that nearly a hundred children would once have been crammed into this former parish schoolroom. The school was built in 1847 for ninety-five infant girls before later becoming a mixed school in 1871. It was finally replaced by Stockwell Street Board School in 1898. The building has a number of interesting features, including attractive ornamental brick framing to the front and rear windows, and some unusual shield-style tiles on the roof. Note also the ornamental brick pier to the left of the gate. After spending many years in a near-derelict condition, the building was finally restored and converted to a private dwelling in 1997.

*Left*: Decorative roof tiling.

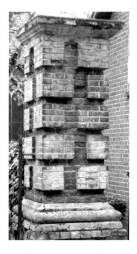

*Right*: Ornamental red and grey brick pier.

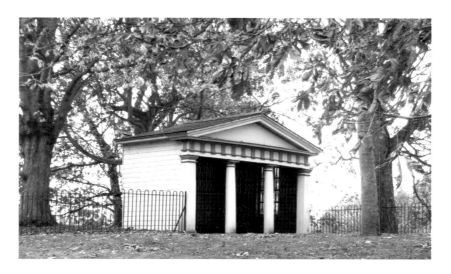

## Summer House, Castle Park

This eighteenth-century summer house, designed in the form of a small classical temple, was erected by Charles Gray (former owner of the nearby castle) in 1731. His diary entry for 24 May 1731 records that it was 'set up at the west end of the terrace'. Charles Gray, together with some of his historian friends, including the eminent Dr William Stukely, seemed to have been of the opinion that the castle was actually the converted remains of some large Roman-built structure (Stukely believed it to have been a former granary), rather than being simply a Norman castle built with Roman materials (see p. 92). So with this in mind it does seem fitting that the summer house incorporates Roman-style decoration to the capitals and frieze.

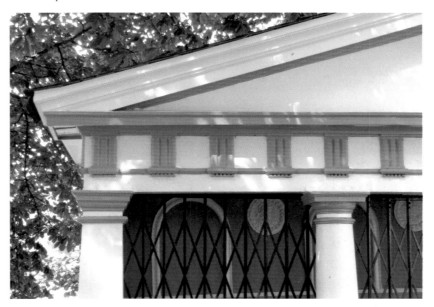

Part of the frieze, showing the triglyphs positioned in the Roman Doric style (compare with Greek Doric on p. 13).

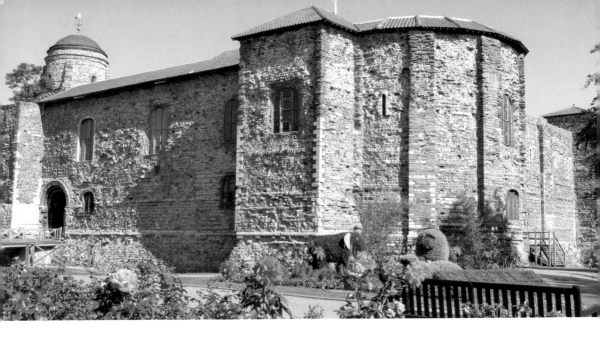

## Colchester Castle

Colchester Castle was built during the reign of William the Conqueror and is the largest surviving Norman keep in Europe. Building work began *c.* 1076 and was completed by around 1100. The building is constructed mainly of recycled Roman brick and septaria and sits on top of the surviving foundations of the former Roman Temple of Claudius, which was erected here following the Emperor's death in AD 54. For situations where quality stone was needed, such as around the door and window openings, other materials, including limestone, were imported from sites as far away as Northamptonshire, Kent and Normandy.

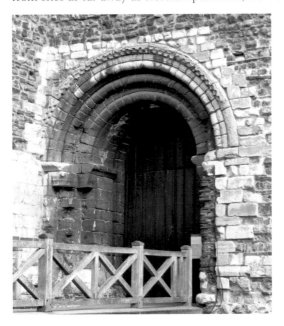

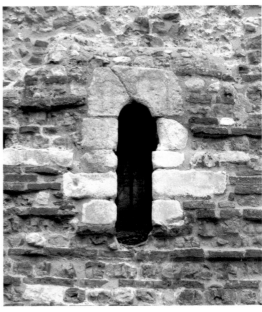

*Left*: Early-twelfth-century main entrance.

*Right*: An original Norman window.

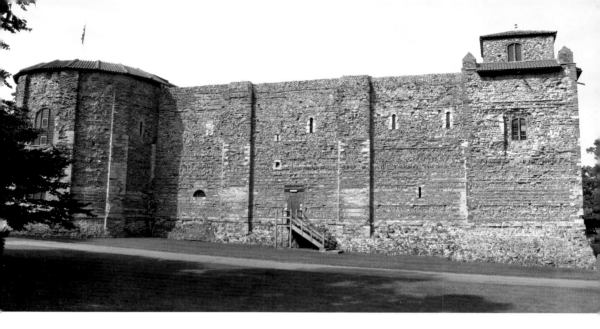

## Colchester Castle

The height of the original castle is not known, although we do know that parts of the upper floors were demolished in the seventeenth century. Whilst the original intention may have been to erect a four-storey building, it may never have been realised. Most authorities now agree that there was probably one more storey than at present – but whether this was just at the corner towers, or across the whole building, is uncertain. It is also apparent that during an early stage of the castle's construction it became necessary to suspend building work and install a series of defensive battlements. These can clearly be identified along the east wall of the castle. Note also the latrine chute and recycled 'hypocaust bricks' at the same level.

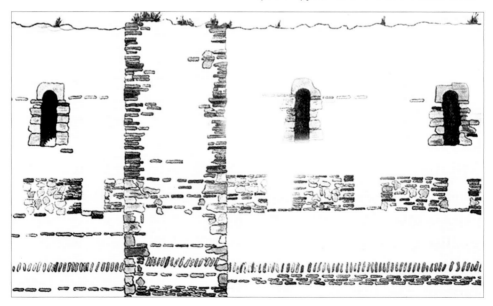

A drawing by K. C. Scarf showing the built-in battlements on the east wall.

# Glossary

**ACANTHUS** A stylised leaf ornament of the Acanthus plant used to decorate the Corinthian capital and to enrich other mouldings.

**APRON** A panel beneath a window which can be blank or decorated with bas-reliefs or other ornaments.

**ARCADE** A series of arches supported by piers or columns.

**ARCHITRAVE** The lowest of the three divisions of a classical entablature. Also used to describe a frame, or similar profile, surrounding a door or window.

**ASYMMETRICAL** Irregular in shape or unbalanced. Not identical on both sides of a central line.

**ATTACHED COLUMN** A column which appears to be partly merged within a wall or pier – also known as an engaged column.

**BALUSTER** A short decorative pillar forming part of a series to support a handrail or coping.

**BALUSTRADE** A series of balusters supporting a handrail or coping.

**BAND** Flat, slightly projecting horizontal strip of masonry or brickwork across the face of a building (see also string course).

**BARGEBOARD** A board, often carved or fretted, which is fixed beneath the eaves of a gable to protect the rafters (also known as a verge board).

**BAROQUE** Style of architecture which exaggerated and embellished the normal conventions of the classical orders.

**BAY WINDOW** Window projecting from the front of a building up a single, or a number of storeys, but always resting on the ground.

**BOW WINDOW** A projecting window of a curved or segmental plan.

**BRESSUMER** A large, horizontal beam supporting the wall above, especially a jettied, or projecting upper floor.

**BRICK NOGGING** The use of bricks to fill in the spaces between the uprights of a timber-frame partition.

**BUCRANIA** Carved representations of ox skulls, often found in the metopes of the Doric frieze.

**CANTED BAY** A bay window with a straight front and angled sides.

**CAPITAL** The uppermost part of a classical column, which gives support to the entablature.

**CARTOUCHE** A raised panel or tablet of elaborate design which may feature an inscription, coat of arms or other decoration.

**CLERESTORY** The uppermost storey of the nave of a church, containing a row of windows. Also high-level windows in a secular building.

**COLONNETTE** Small column or shaft.

**COLUMN** In classical architecture, an upright structural member, of circular section, containing a shaft, capital and usually a base.

**COMPOSITE** One of the classical orders where the capital combines the volutes of the Ionic order with the acanthus foliage of the Corinthian order.

**CONSOLE** Classical scrolled bracket.

**COPING** A protective course of stone or brickwork capping a wall or balustrade.

**CORBEL** Projecting block of stone or timber to support a feature above.

**CORINTHIAN** One of the classical orders which is easily identified by the stylised acanthus foliage on its capital.

**CORNICE** The uppermost section of the three divisions of a classical entablature. Also a horizontal decorative moulding at the junction of the walls and ceiling in a room.

**DECORATED** A period, or style, of English Gothic architecture *c.* 1280–1380, particularly known for its more elaborate and flowing window tracery.

**DENTILS** Closely spaced square or tooth-like blocks found in the cornices of Ionic, Corinthian and Composite orders.

**DOORCASE** Case or frame lining a door opening – especially one that is large and imposing.

**DORIC** One of the classical orders developed in slightly different ways by the Greeks and the Romans. One common feature being the presence of triglyphs in the frieze.

**DORMER** Window projecting from a sloping roof and providing light to the attic rooms.

**DRESSINGS** Brick or stonework flanking a wall opening, or adjacent to a corner, that is treated differently from the remainder of the wall face.

**EAVES** The overhanging edge of a roof, often with a facia board to support the guttering.

**ENGLISH BOND** A bond for laying bricks using alternate courses of headers (short ends) and stretchers (long sides).

**ENTABLATURE** In classical architecture, the collective name for the uppermost order of architecture consisting of the architrave, frieze and cornice.

**FAÇADE** The external elevation of a building – especially its front elevation.

**FANLIGHT** Window over a door, often semicircular and having radial glazing bars resembling a fan.

**FINIAL** The ornamental top part of a spire or pinnacle.

**FLUTES** In classical architecture, repeated concave channels cut vertically into the face of a column.

**FRIEZE** The central part of the entablature, lying above the architrave and below the cornice.

**GABLE** The triangular upper section of a wall at the end of a pitched roof.

**GAUGED BRICKWORK** Soft bricks that have been sawn to shape and then rubbed to a smooth surface and precise dimensions (also known as 'rubbed bricks').

**GAULT BRICK** Bricks made from Gault clay which are normally an off-white or yellowish colour, but may vary in shade.

**GIBBS SURROUND** A door or window surround made popular by James Gibbs (1682–1754), in which the architrave is interrupted by plain blocks.

**GOTHIC** A style of architecture that flourished during the high and late medieval period. One of its main identifying features being the pointed arch.

**HOOD MOULD** A moulding above a door or window designed to protect the opening from water running down the wall.

**HYPOCAUST** Roman under floor heating system.

**IN ANTIS** Where the columns of a porch are positioned on the same line as the front of the building.

**IONIC** One of the classical orders which is characterised by the spiral volutes in its capital.

**JETTY** An upper floor that projects over a lower wall in timber frame construction.

**KEEP** The main central tower of a castle.

**KEYSTONE** The central wedge-shaped stone at the top of an arch.

**LUNETTE** Semicircular window.

**MANSARD ROOF** A roof divided into two pitches, the lower part steeper than the upper.

**MASCARON** A grotesque head or face, often used to adorn keystones and other prominent parts of a building.

**MODILLIONS** A series of small scroll or square shaped brackets found beneath a cornice.

**NAVE** The main body of a church, often flanked by side aisles.

**NICHE** Arched recess in a wall, often used to accommodate a statue.

**ORIEL WINDOW** A projecting window supported on brackets and corbels.

**PARAPET** The top section of a wall that continues above roof level, often to conceal a gutter or the roof itself.

**PARGETTING** A raised pattern formed from plaster on an external wall.

**PEDESTAL** In classical architecture, a tall block supporting a column.

**PEDIMENT** In classical architecture, a triangular or segmental low pitched gable used over porticoes, doors and windows.

**PILASTER** A flat representation of a column attached to a wall and projecting slightly from it.

**PODIUM** A solid platform, or foundation, upon which a classical building is placed.

**PORTICO** The classical columned porch at the entrance to a temple or other building.

**PUTTI** Decorative figures of small cupid-like children.

**QUOINS** Corner stones placed to give emphasis at the angle of a building.

**ROMANESQUE** Style of architecture current in the eleventh and twelfth centuries. In England traditionally referred to as Norman architecture.

**RUSTICATION** Exaggerated treatment of masonry, or stucco, by emphasising each block by the use of deeply recessed joints.

**SASH BOXES** Boxed frame that housed the sash cords and weights.

**SASH WINDOWS** Window with two vertically sliding glazed frames.

**SCREENS PASSAGE** Partially screened-off entrance passage between the great hall and the service rooms.

**SEGMENTAL** Curved shape that is formed out of a small segment of a circle (segmental arch or pediment etc.)

**SEPTARIA** A kind of stone formed by compacted clay nodules, which occur in the outcropping of the London clays – especially at the coastal regions.

**SHAFT** In classical architecture, that part of a column which is between the base and the capital.

**SHOULDERED – ARCHITRAVE** A moulded frame of a door or window with horizontal and vertical projections at the top angles (also eared architrave).

**STRAPWORK** Decoration representing strap-like bands, which are often interlaced.

**STRING COURSE** A slightly projecting horizontal band of brick or stone running across the face of a building, usually at intermediate floor level.

**STUCCO** A plaster or cement rendering to the face of a building, either plain or sometimes in imitation of stonework.

**SWAG** A decorative festoon of fruit, flowers or foliage suspended from both ends.

**TETRASTYLE** A portico or porch containing four columns.

**TIMBER-FRAME** Method of construction where the structural frame is formed by interlocking timbers.

**TRIFORIUM** An arcaded wall passage found in a church just below the clerestory, and level with the aisle roof.

**TRIGLYPHS** The vertical triangular grooves found in the panels of a Doric frieze.

**TUCK POINTING** A method of pointing in which lime putty is inserted into precisely cut grooves cut into a mortar joint that matches the colour of the brickwork. The result gives the illusion of thin joints in fine quality brickwork.

**TUSCAN** A style of architecture which is a simpler version of Roman Doric.

**UMBRELLO** Small, temple-like garden house positioned as a resting place along a terrace or walk.

**VENETIAN WINDOW** In classical architecture, a window with an arched central light flanked by two lower straight-headed ones.

**VOLUTES** Spiral scrolls typically found on Ionic capital.